# SOUTH AFRICA

*magic land*

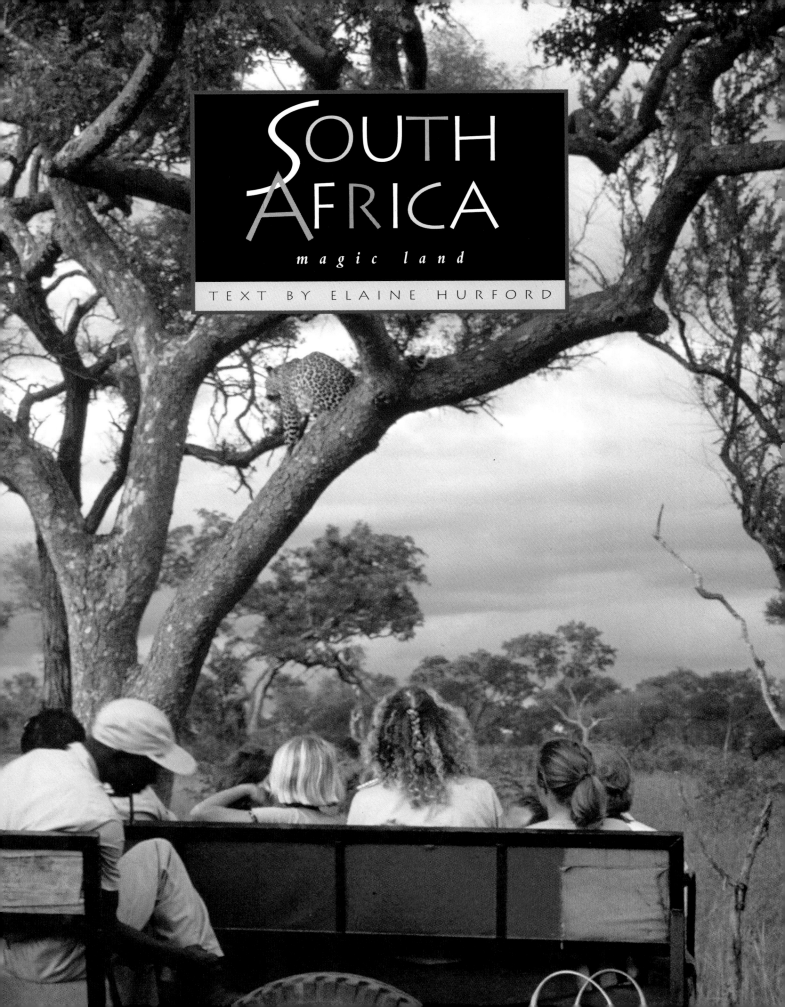

# SOUTH AFRICA

*magic land*

TEXT BY ELAINE HURFORD

Struik Publishers (Pty) Ltd
(a member of The Struik Publishing Group (Pty) Ltd)
Cornelis Struik House, 80 McKenzie Street
Cape Town 8001

Reg. No. 54/00965/07

First published by Struik Publishers (Pty) Ltd 1995
Second impression 1996
Third impression 1997
Fourth impression 1998

*Editors* Lesley Hay-Whitton and Pippa Parker
*Managing editor* Annlerie van Rooyen
*Project co-ordinator* Christine Didcott
*Designer* Odette Marais
*Proofreader* Thea Coetzee
*Cartographers* Renée Barnes (main map) and Steven Felmore (thumbnail maps)

Reproduction by Adcolour (Cape) (Pty) Ltd
Printed and bound by Tien Wah Press (Pte) Limited, Singapore

ISBN 1 86825 771 1

Copyright © of the photographs rests with the following photographers and/or their agents:

**ABPL** = ABPL Photo Library    **CLB** = CLB Publishing    **NPB** = Natal Parks Board    **SIL** = Struik Image Library

**Shaen Adey:** Front cover **(SIL)**, back cover (all **SIL** except for the sunflowers), pp. 5, 45, 46 (bottom), 54 (centre), 56 (bottom), 57 (top and bottom), 60 (top left and right), 63 (left), 73 (left), 102, 103 (top), 108, 110, 117 (left), 122 (top), 125 (top), 133 (top), 136 (middle). **Airtrack Adventures (Pty) Ltd:** p. 26 (top). **Daryl Balfour:** pp. 135, 138, 140 (top). **Anthony Bannister (ABPL):** pp. 31 (top), 50 (bottom), 104-5 (bottom). **Michael Brett:** p. 38. **David Bristow (Photo Access):** p. 29 (left and right). **CLB/SIL:** pp. 16 (main picture), 18 (top), 59, 67, 101 (main picture), 107 (main picture). **Steve Corner (Photo Access):** p. 111 (top). **Pat de la Harpe:** p. 62. **Roger de la Harpe:** pp. 43 (top), 50 (centre), 51 **(NPB)**, 52 **(NPB)**, 53 **(NPB)**, 54 (top and bottom) **(NPB)**, 55 **(NPB)**, 56 (top) **(NPB)**, 58 (bottom), 60 (bottom) **(ABPL)**, 61, 63 (left and right), 64 (bottom left), 64 (bottom right) **(ABPL)**, 68 (top), 71 (top), 97 (top), 97 (bottom right) **(ABPL)**, 120 (top) **(ABPL)**. **Nigel Dennis:** pp. 27 **(SIL)**, 39 (top), 97 (bottom left), 104 (top), 107 (top). **Charles Didcott (courtesy of Felix Unite):** p. 106. **Gerhard Dreyer:** pp. 1, 11 **(SIL)**, 85 (left), 86 **(SIL)**, 91, 92 **(SIL)**, 93 (bottom) **(SIL)**, 94 (bottom) **(SIL)**, 95 (top and bottom) **(SIL)**, 111 (bottom), 113 (bottom), 114 (top and bottom). **Richard du Toit (ABPL):** pp. 42 (bottom), 43 (bottom). **Aubrey Elliot:** pp. 20 (top right, and bottom). **Pat Evans:** p. 58 (top left). **Craig Fraser:** p. 129 (bottom). **Ken Gerhard (Stocks Leisure Developments (Pty) Ltd):** p. 26 (bottom). **Clem Haagner (ABPL):** pp. 40-1 (bottom), 105 (top). **Lesley Hay (ABPL):** p. 37. **Leonard Hoffmann (SIL):** p. 76 (centre). **P. John (SIL):** p. 80. **Walter Knirr:** pp. 6, 7, 9, 12 **(Photo Access)**, 15 (top right and bottom), 19 (top and bottom), 21, 23 (left) **(Photo Access)**, 23 (right), 24 (top), 28, 30, 31 (bottom), 32 (top and bottom), 34, 35 (top and bottom), 47, 48-9 **(Photo Access)**, 64 (top) **(Photo Access)**, 68 (bottom), 69 **(Photo Access)**, 70 **(Photo Access)**, 87 **(Photo Access)**, 90, 96, 98, 99, 115, 116, 124, 132, 134. **Anne Laing:** p. 17 (bottom). **Mark Lewis:** p. 20 (top left). **Jean Morris (Photo Access):** p. 13 (right). **Jackie Murray:** pp. 13 (left) **(SIL)**, 14 (bottom) **(SIL)**, 16 (inset) **(SIL)**, 17 (top) **(SIL)**, 18 (bottom) **(SIL)**, 120 (bottom). **J.C. Paterson-Jones:** p. 89. **M. Patzer:** p. 109. **Peter Pickford (SIL):** pp. 50 (top), 76 (top), 77, 81, 88 (bottom), 103 (bottom). **Herman Potgieter:** pp. 72, 74 (left), 75 (top), 75 (main picture) **(ABPL)**, 83. **Alain Proust:** pp. 2-3, 10, 22, 24 (bottom), 25, 36, 42 (top), 119 (top right and bottom left), 122 (bottom right), 123, 127, 129 (top), 130 (bottom left), 137. **Joan Ryder (ABPL):** p. 15 (top left). **Lorna Stanton:** pp. 39 (bottom) **(ABPL)**, 40 (top left and right), 41 (top). **David Steele (Photo Access):** pp. 100, 101 (bottom). **August Sycholt:** p. 44. **Janek Szymanowski:** p. 93 (top). **Erhardt Thiel (SIL):** pp. 112, 113 (top), 117 (right), 118, 119 (top left and bottom right), 121 (main picture), 122 (bottom left), 125 (bottom), 128, 130 (top, and bottom right), 133 (bottom), 136 (top and bottom), 140 (bottom), 141 (top). **Lisa Trocchi (ABPL):** p. 14 (top). **Mark van Aardt:** pp. 94 (top), 139. **Chris van Lennep:** pp. 66, 71 (bottom). **F. von Hörsten:** pp. 73 (right), 82 (bottom). **Lanz von Hörsten:** p. 126 (top). **Hein von Hörsten (ABPL):** p. 131. **Patrick Wagner (Photo Access):** pp. 33, 58 (top right), 84, 85 (right), 88 (top). **Keith Young:** pp. 46 (top), 65, 76 (bottom), 78, 79 (top and bottom), 82 (top), 121 (bottom), 126 (bottom), 141 (bottom), 142, 143.

Grateful thanks are extended to **Airtrack Adventures (Pty) Ltd, Stocks Leisure Developments (Pty) Ltd** and **Felix Unite** for the use of their photographic material.

**Page 1** Brilliant displays of wild flowers briefly cover the dry landscapes of the Karoo, Namaqualand and Cape interior in spring.
**Pages 2-3** Game-viewing in Londolozi, a private luxury reserve in the Lowveld.
**Page 5** Fields of heavy-headed sunflowers bloom in the high-lying Free State.

# CONTENTS

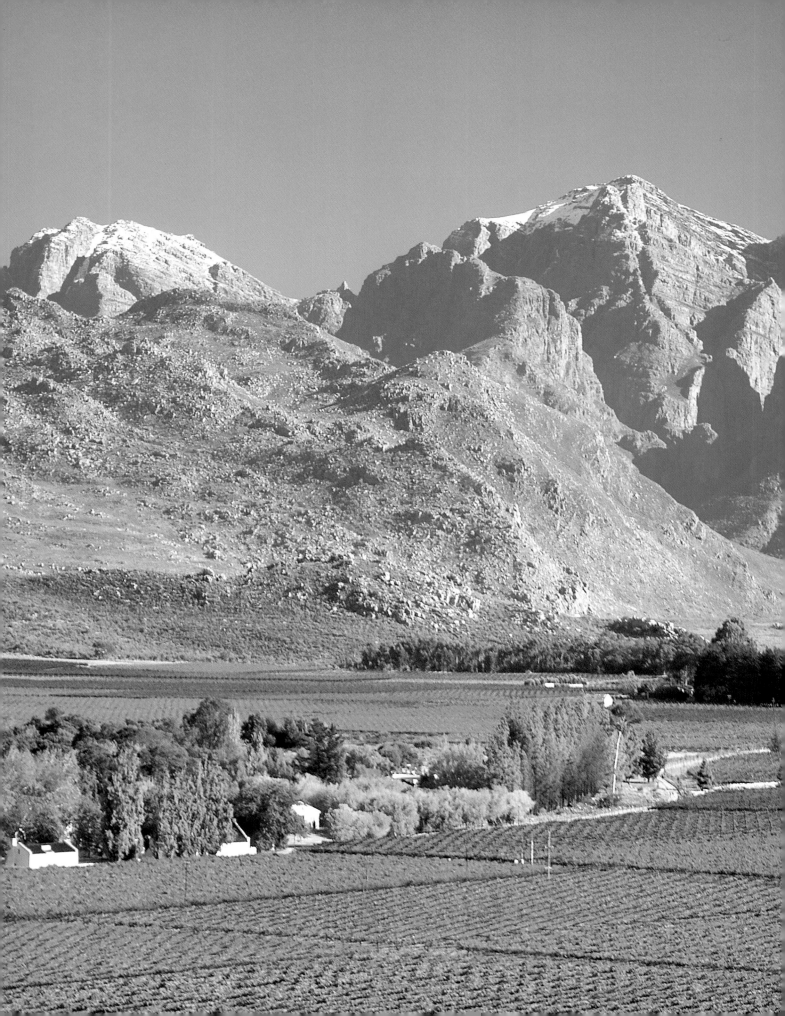

# INTRODUCTION

**W**HILE POLITICAL DEVELOPMENTS MAY have put South Africa back on the international tourist map, it will be her assets that keep her there. Hardly any other country on earth has been blessed with such a captivating array of natural treasures: majestic mountains, high golden plains, forested coastal terraces, unspoilt beaches and the world's most varied assembly of game free to roam in vast natural sanctuaries.

The country, 1,2 million square kilometres in extent, lies between two mighty oceans, the Indian and the Atlantic, with 3 500 kilometres of shoreline providing unlimited opportunities for leisure and pleasure. The oceans, too, provide South Africa with a generous bounty of seafood which has a place of honour on the national table alongside the game, excellent mutton and beef, fruit and fine wines for which the country is renowned.

The oceans and mountains impact significantly on the climate and ecosystems of the country. The cold Benguela Current sweeping along the Atlantic West Coast is partially responsible for the creation of a coastal desert with extraordinary plant forms and stark landscapes; the mild Agulhas Current combines with the Indian Ocean to give the East Coast a temperate (and in places subtropical) climate which supports a lush green belt. It is at Agulhas, about 200 kilometres east of Cape Town, that the oceans meet. Here, on a rocky, windblown beach, is the southernmost tip of the continent of Africa.

The mountains help to create South Africa's sunny, dry climate, but they also deprive the interior of much-needed rain. From the north-eastern Transvaal through the southern and western Cape, the mountains cup the entire sub-continent in a mammoth horseshoe. The interior is cyclically wracked by devastating droughts which decimate crops and livestock, emptying the nation's food store and causing untold hardship for millions of rural people.

LEFT Winter brings a blanket of snow to the Hex River mountains. In the valley, the vines lie ready to produce the next crop of fine export table grapes. ABOVE The crane flower with its bold orange and blue colouring.

Untouched by the weather, South Africa's precious store of mineral wealth lies deep beneath the sunbaked surface. Gold, diamonds, platinum, chromium and nickel are among a total of around 60 mineable minerals; oil and natural gas have been charted along the southern coastline. Wealth of a different kind lies buried in the fossils of the Karoo, one of the world's most comprehensive, unbroken records spanning 50 million years. Once the foundation of the country's wealth, South African gold, although still the most valuable export commodity, has been superseded by manufacturing as a

major contributor to the gross domestic product. The manufacturing industry contributes 22 per cent, followed by financial services, mining, commerce, the informal sector, agriculture, forestry and fishing, and finally electricity, gas and water installations.

Tourism, since South Africa's entry into democracy, is already making a major contribution to the coffers and is being punted as a possible contender to overthrow mining, and perhaps even industry, as a national money-spinner. It is estimated that every ten visitors create one much-needed job.

Infrastructures for tourism are undergoing urgent attention. National and regional tourism organizations are brushing up on marketing and standards. Sweeping regrading systems for the hospitality industry will see even small bed and breakfast establishments, that are erupting in response to urgent needs for informal accommodation, subjected to classification.

The excellent national road network covers 240 000 kilometres, of which some 100 000 kilometres is tarred. Visitors can travel by rail (36 000 kilometres) or air. South Africa's national carrier and more than 20 other airlines are competing for the business of bringing foreign tourists into the country for the holiday of a lifetime, starting at any one of three international airports. Two decades after the last of the Union Castle liners called at Table Bay, luxury passenger cruise ships are beginning to reappear at major ports throughout the country.

But what gives a country life is her people. Depending on their origins and attitudes, the people of South Africa have been anxious or exhilarated by the fast-moving events of the last few years. Nothing will ever be the same again, and, for the vast majority of South Africans, to take ownership of optimism and opportunity after generations of unequal division is glorious, heady stuff. There is a sense of national energy, a drawing on collective reserves to secure the future of this lovely land.

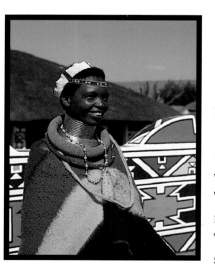

BELOW The graphic elements and colours of Ndebele art have been adapted for use in fashion and interior design.

South Africa's democratically-termed 'rainbow nation' is composed of 40 million multi-hued people united — or, sadly, more often not — by a history woven of territorial confrontation and racial conflict. European conquerors and colonists first encountered the San people in the southern Cape in the fifteenth century. Their delicate rock art, fairly widely distributed throughout the country, is all that remains of the pastoralists who respected the precarious balance of nature and lived in harmony with man and beast.

The cattle-owning Khoikhoi, seeking grazing, were the first to initiate conflict with the San, driving them from the western, central and southern parts of the subcontinent. They were followed by the 'black', tribal people who migrated southwards until by the mid-1600s the Sotho and Tsonga had occupied large areas of the interior, and the southern Nguni (the Xhosa people), the Eastern Cape.

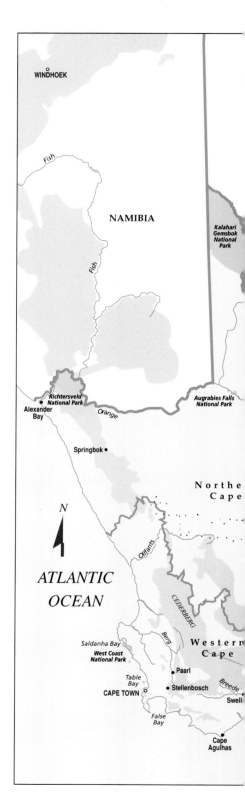

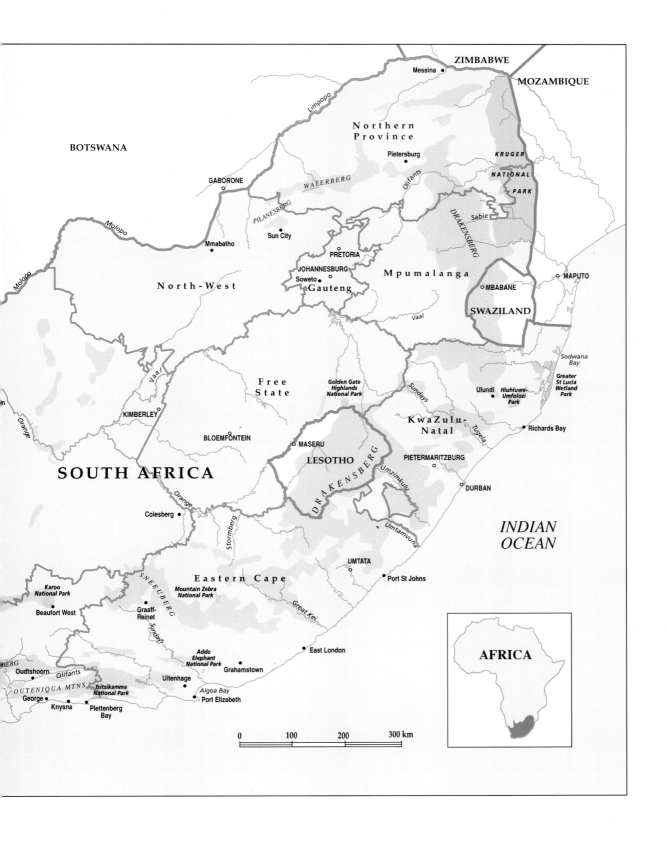

The powerful European nations, custodians of the 'civilized world', were in the meantime seeking to expand their empires with foreign acquisitions: Portugal, Spain, Great Britain and the Netherlands were participating in a race which held new colonies, wealth and further power as the prizes.

The first to meet the southern African pastoralists were the Portuguese, in fleeting and sometimes bloody encounters in the fifteenth and sixteenth centuries. However, when the Dutch landed in Table Bay in 1652 with the specific intent of establishing a halfway station en route to the East, they had clear instructions to remain on friendly terms with locals. The idea was to barter cattle to supply passing ships with fresh meat. There was originally no plan to establish a new colony. After a few years, however, staff at the Cape of Good Hope became dissatisfied and started going back home. Numbers at the supply station dwindled and, to motivate his people to remain in the country, Jan van Riebeeck freed his burgers to develop farms in the hinterland. The Cape was beginning to take on the appearance of a colony – aided by the arrival in 1688 of the Huguenots who fled France to escape religious persecution.

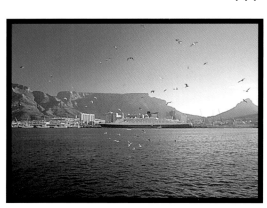

ABOVE  Table Bay, gateway to Africa. For almost 400 years, visitors arriving at the Cape – whether in stately sailing ships, steamers, mailships or, nowadays, the most luxurious modern cruise liners – have been thrilled and awed at the sight of Table Mountain.
OPPOSITE  Nature's Valley on the Garden Route, in the Tsitsikamma National Park, is a lovely spot for walking and bird-watching.

Not much more than a century later, the Dutch East India Company was in ruins and the British occupied the Cape – for the first time. In the meantime, the Hottentots' centuries-old societal and economic structures were being fragmented by the impact of the European settlers; clans fought to acquire trade with the Dutch. Some stayed, others moved off into the uncharted interior and a future fraught with uncertainty.

As the British colony grew, augmented by the 1820 Settlers and German reinforcements required to man its eastern boundaries, so the fabric of a history of inter-racial clashes and imperialism was woven over a hundred years.

The first South Africans, the indigenous tribes, are today distributed throughout the country: the Xhosa in the Eastern Cape; the Zulu in KwaZulu-Natal; Ndebele, Venda, Tsonga and Shangaan in the Transvaal; the Sotho-Tswana people in Mmabatho and Mafikeng; and the South Sotho group in QwaQwa, or eastern Free State.

Numbers at the small Cape Colony swelled as slaves were brought from Madagascar, Angola and Delagoa Bay; political and royal exiles from the East were put out of harm's way at the Cape; indentured labourers were brought from India to work the Natal sugar plantations and settlements at the Cape continued over the next hundred years with immigrants from the homelands.

Today, South Africa is a pot-pourri of cultures and colour composed of multiple influences: Indian, Muslim, Portuguese, British, French, Dutch and German – they've all made a lasting contribution to a richly-woven national tapestry. And, against a bloody background of tumult and tragedy, South Africa has emerged with the rainbow intact and a nation held together by bonds deeper than the events of a mere few centuries. Theirs – if, as is widely assumed, Africa is the birthplace of humankind – is the history of man itself.

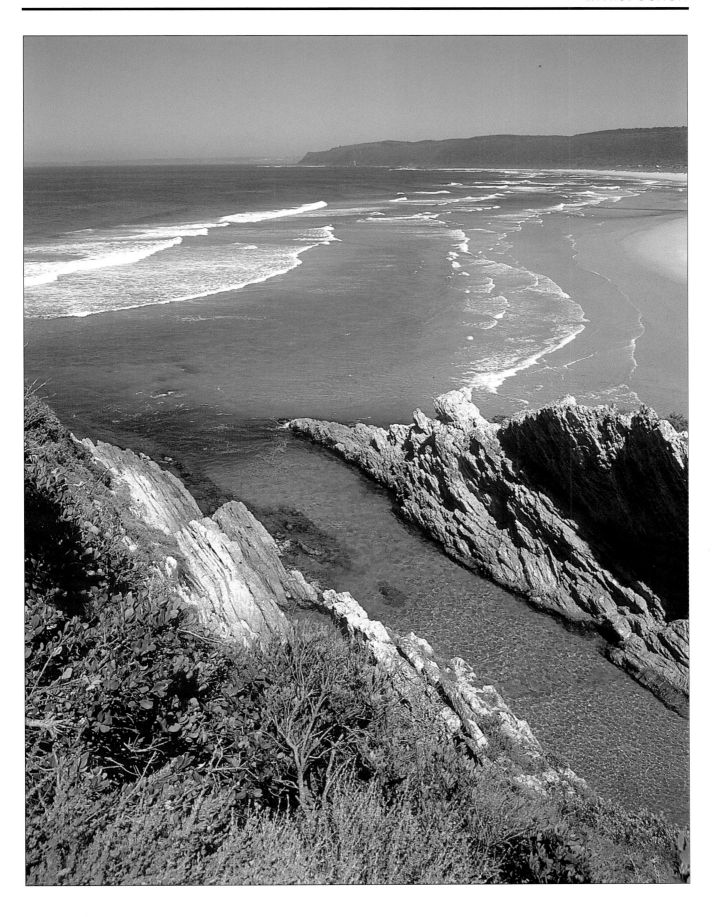

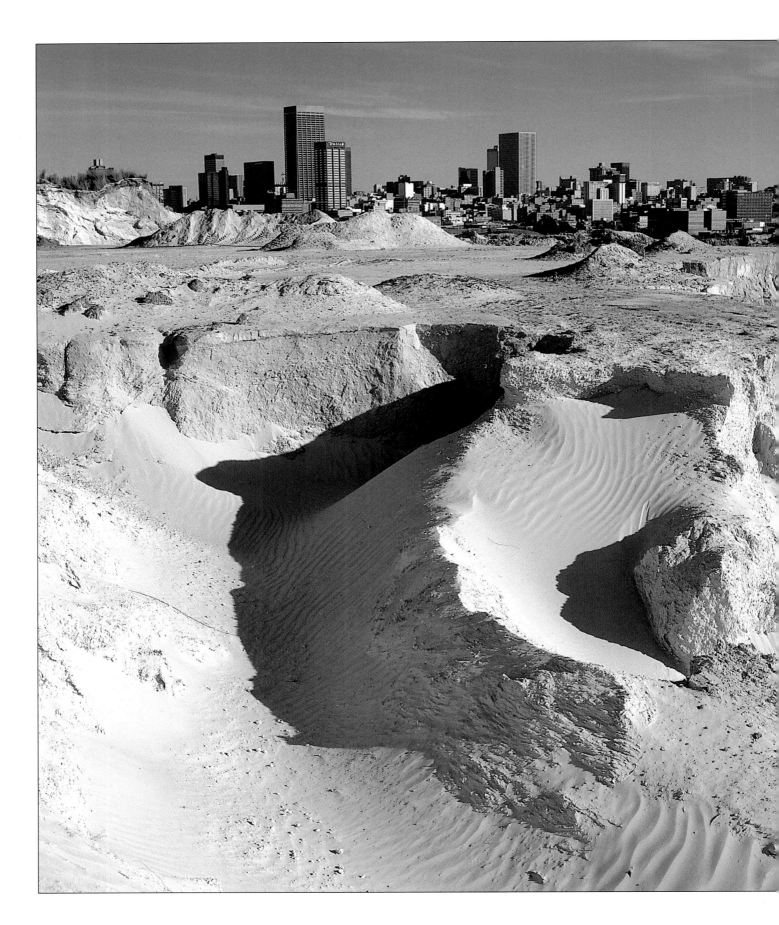

# JOHANNESBURG AND PRETORIA

*The brazen and the beautiful*

JOHANNESBURG DANCES TO ITS own drumbeat. A vibrant, tempestuous, modern African city, unlike any other, Johannesburg is a world in itself. Africa on first impact is almost always overwhelming and Johannesburg, the biggest city in Africa south of Cairo, is no exception. It is here that most foreign tourists enter South Africa, via Johannesburg International Airport. The city is home to about six million official residents and who knows how many uncounted hopefuls, lured by the promise of work and shelter to a city that always seems to have room for more.

Johannesburg is the seat of financial and industrial power — home of the Stock Exchange and headquarters of the world's greatest mining houses. Built on the richest gold-bearing reef ever discovered, Egoli, the City of Gold, has all the trappings — and the seedy underbelly — of wealth.

In the city centre, pavement vendors jostle for space with passengers pouring in and out of the minibus taxis. The minibuses shuttle between the city and vast townships like Soweto — with wryly named suburbs such as 'Beverly Hills' — that sprawl across the bushveld south and west of Johannesburg.

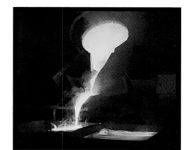

Beyond the high-rise CBD and the multi-racial flatlands of Hillbrow, Berea and Yeoville, the more affluent residential areas spread northwards: green belts studded with opulent shopping malls stuffed with luxury goods. Many of the grandest homes here recall *la belle époque* when powerful Randlords made fortunes out of gold. To the south and west lie the goldfields; some, like Western Deep Levels, delving to 3,5 kilometres below the surface.

While Johannesburg is the seat of financial power, Pretoria, 56 kilometres north, holds the administrative and diplomatic reins of the country. Planned around glorious parks and gardens, the city in spring is bathed in a lilac light

FAR LEFT  The metropolis of Johannesburg, or Egoli (City of Gold), rises from a desert of mine-dumps at the heart of the African subcontinent.
LEFT  Johannesburg: home to a colourful array of people.
ABOVE  Gold, originally the glittering foundation of the nation's wealth.

cast by thousands of jacarandas in full blossom. The old capital of the first South African Republic, Pretoria features many relics of the Boers' dreams and glories. Most notable is the monolithic Voortrekker Monument, commemorating the Great Trek of the previous century and the achievements of all those who took part. The Union Buildings, designed by Sir Herbert Baker, were the traditional seat of the Nationalist government; here, in May 1994, Nelson Mandela was inaugurated as President of a new democratic South Africa.

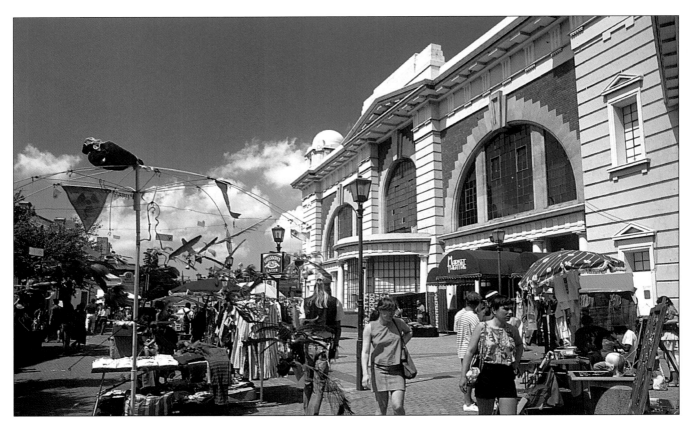

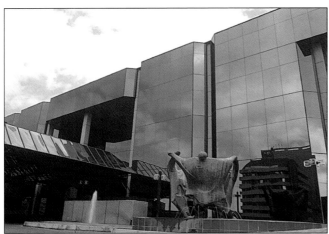

ABOVE  Informal traders ply their bright wares outside the Market Theatre in downtown Johannesburg. Many entrepreneurs start out in the flea markets before moving on to more formal retail enterprises. For others, 'doing the markets' is a way of life which means travelling from centre to centre, following the annual calendar of provincial events.

Throughout the city, vendors sprawl their wares along the pavements, and it's possible to buy anything – from peanuts and fruit, to socks, watches and leather goods – off the street.

ABOVE LEFT  Johannesburg's imposing Civic Centre reflects a turbulent Transvaal sky. The fabric of the city is evenly woven from the old and the new, often with surprising juxtapositions of prismatic glass structures towering alongside Victorian relics.

RIGHT AND BELOW Gold Reef City has been developed around mine workings on the southern limits of the city. The essence of the early gold era is recaptured in a vibrant theme park with Victorian funfairs, museums, restaurants, bars and lodgings with 'Accommodation for Man & Beast'.

FAR RIGHT Miners abandon their overalls and don traditional garb for the exuberant dancing displays held at Gold Reef City and at the Gold Mine Museum.

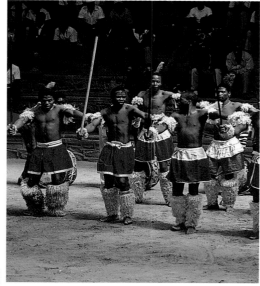

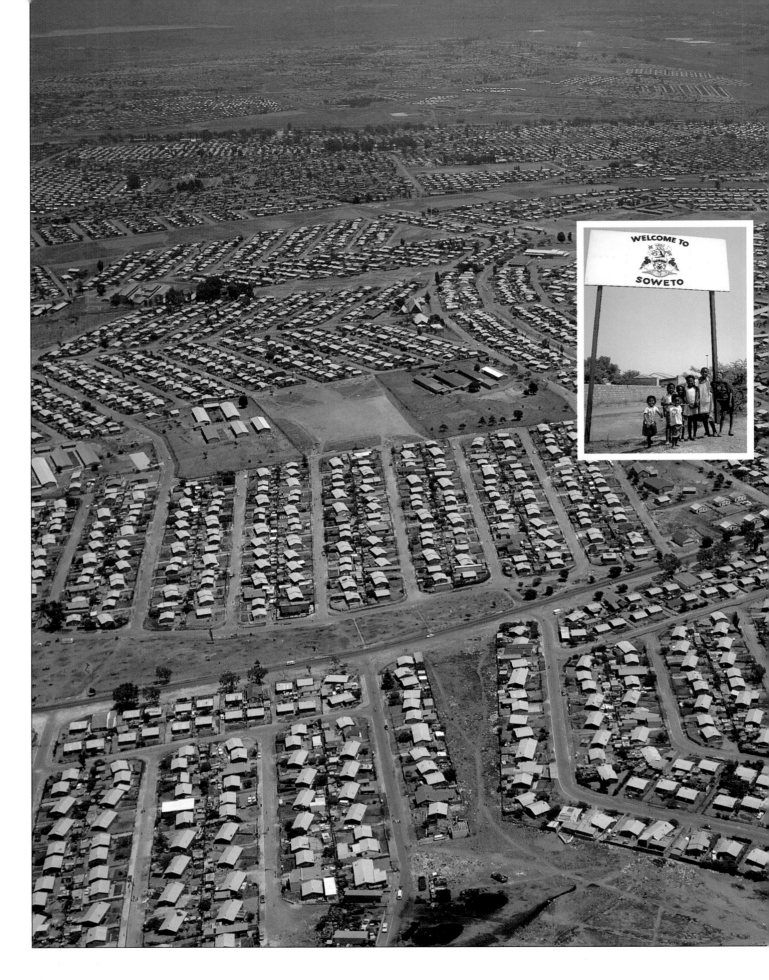

Welcome to Soweto

OPPOSITE With its roots firmly in the squatter camps that sprang up around Johannesburg's mining activities between the 1930s and 1940s, the vast residential area of Soweto – an acronym for SOuth WEstern TOwnships – was constructed to provide housing for the thousands of people who flocked to the Reef in search of work at that time.

INSET OPPOSITE A 'welcome committee' clusters at one of the entrances to Soweto.

RIGHT A supporter signals victory after a match between Kaizer Chiefs and QuaQua Stars.

BELOW Vast crowds of supporters flock to the Rand Stadium in Johannesburg's southern suburbs to witness sporting battles of epic proportions between the nation's soccer teams.

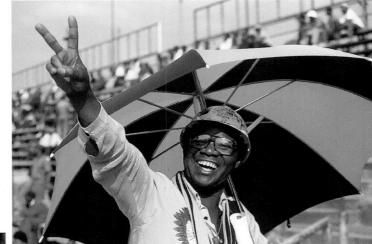

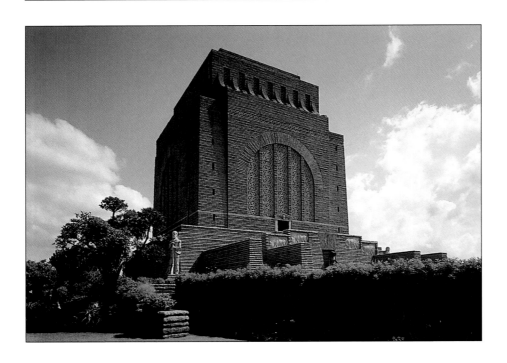

OPPOSITE TOP  Blooming jacaranda trees line the streets, and their blossoms (often creating a slippery pedestrian hazard) carpet the pavements of Pretoria in spring.

BELOW  The Union Buildings in Pretoria, where Nelson Mandela was inaugurated as the first President of a new democratic South Africa in May 1994. The sandstone structure, designed by architect Sir Herbert Baker, is set in park-like gardens. A statue commemorating General Louis Botha, first Prime Minister of the Union of South Africa, commands the foreground.

ABOVE  The 40-metre-high Voortrekker Monument, which was begun in 1938 and completed in 1949, commemorates the Voortrekkers' Great Trek of the 1830s. Artefacts in the small museum on site show how the trekkers lived. The panorama of Pretoria can be seen from a vantage point at the top of a staircase within the monument.

BELOW  A statue of Paul Kruger, father of the Afrikaner nation and president of the first *Zuid-Afrikaansche* (South African) Republic.

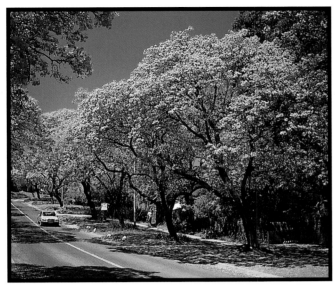

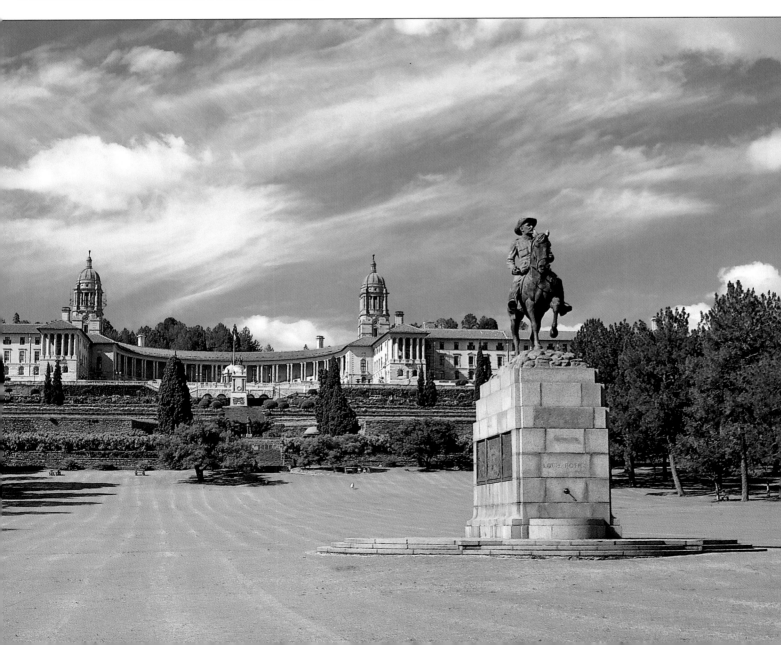

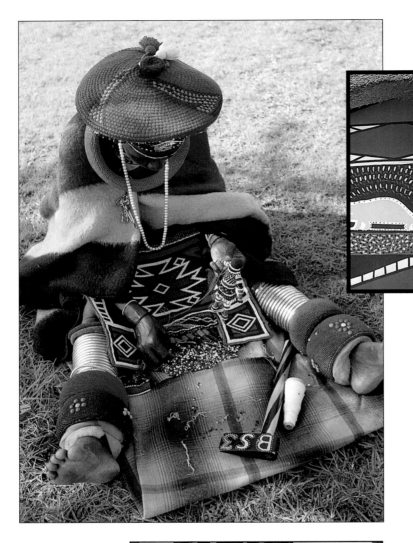

LEFT An Ndebele woman, dressed in traditional clothing, making the beaded marriage apron worn by a bride at her wedding ceremony.

ABOVE A typical Ndebele mural, showing the characteristic vibrant colours and geometric forms of the art.

BOTTOM LEFT Generally, young girls wear beaded aprons *(lighabi)* before reaching puberty, but little boys may also wear them.

OPPOSITE The accessories worn by Ndebele women each point to their status in life. The beaded hoops *(golwani)* are adornments worn by initiated girls and married women, the metal rings *(dzilla)* worn around the legs, arms and neck are charged with ritual meaning and are worn by married women only. The blanket, another symbol of status, is given to a woman on the solemnization of her marriage and is often decorated with attractive beaded strips.

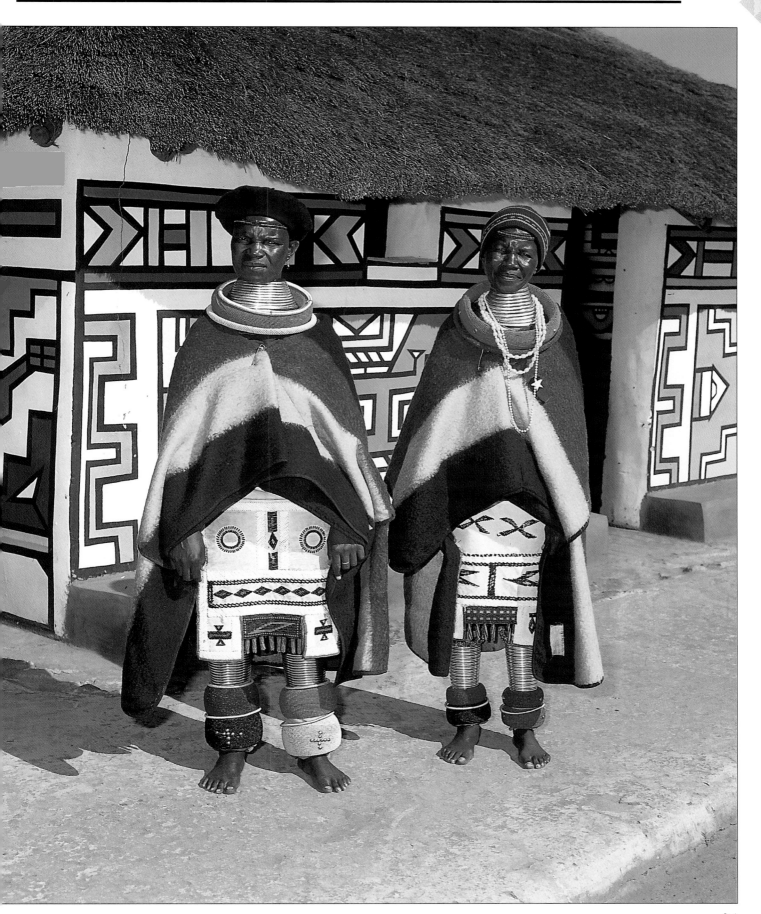

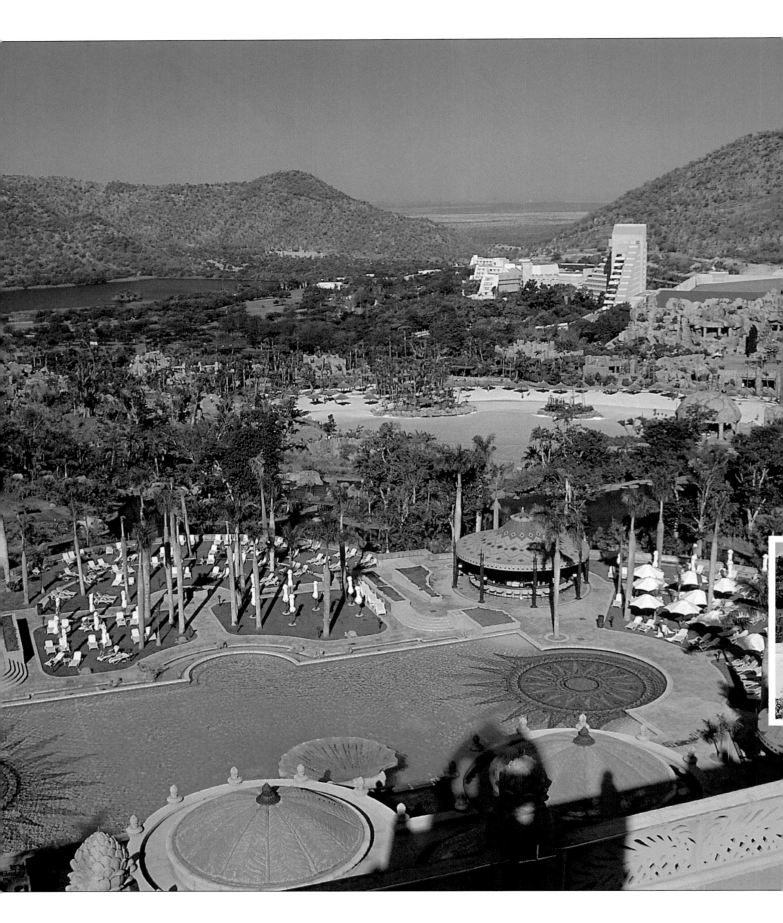

# SUN CITY AND THE LOST CITY

*Dreams from the dust*

I N THE CENTRE OF a volcanic valley surrounded by the dun slopes of the Pilanesberg mountains, a wilderness wonderland rises from the dust. Shimmering in the African sun, the fantastic Sun City Resort Complex could be mistaken for a mirage. In reality, it's a vision realized through a multi-million-dollar investment and one man's unshakable faith in the religion of tourism – South African hotel prodigy Sol Kerzner.

The dream began with a middle-of-nowhere luxury hotel in the sun. It soon evolved to include a second sumptuous hotel, the Cascades, with tropical gardens, a flamingo lake lapping the edge of the building, rushing waterfalls and a Sky Train which whisks visitors between destinations within the resort.

Then Sol Kerzner's imagination looped the loop in a defiant free fall and he built his ultimate fantasy – the 'recreation' of a Lost City which, legend has it, was inhabited by gentle people of an ancient civilization.

The Lost City has at its centre a 'palace' of impossible opulence guarded by towering elephants lining an immense bridge; it is ringed with man-made lakes stocked with rare birds and fish, pools, forests and a tropical beach with perfect surfing waves – electrically generated. Lit with the glow of a million candles, the Palace is decorated with Renaissance frescoes, hand-carved furniture, mosaic-inlaid floors and towering columns of false tusks and palm fronds.

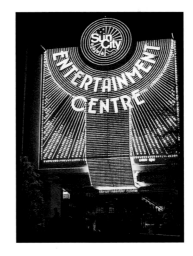

Today the Sun City Resort Complex is one of the world's largest adult entertainment centres, a luxury theme park for grown-up kids. And, when the day's play is over, there are beds for more than 2 000 guests.

FAR LEFT A glittering fantasy realized in the wilderness: the Sun City Resort Complex in former Bophuthatswana. LEFT Sun-worshippers flock to the shores of a tropical 'beach' at the 'Valley of the Waves' at the Lost City. ABOVE The round-the-clock Entertainment Centre, Sun City's enormous pleasure complex, blazes an invitation into the bushveld night.

Out of doors, two championship golf courses – one with crocodiles at the thirteenth hole – are bordered by the Pilanesberg National Park (containing the 'Big Five' – elephant, lion, leopard, rhino and buffalo) where a vigorous conservation programme has resulted in more than 300 rhinos numbered among the 10 000 animals in the reserve. The 55 000-hectare park is the third biggest game reserve in southern Africa. Game-viewing can be enjoyed from specially adapted four-wheel-drive vehicles, or Kerzner-style, from the lazy heights of a hot-air balloon, and followed by a sumptuous bush breakfast.

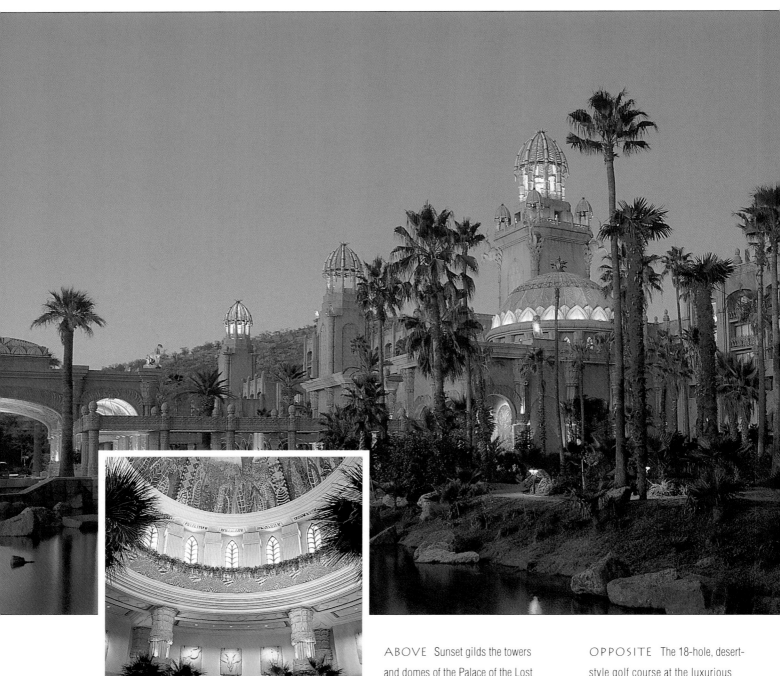

ABOVE  Sunset gilds the towers and domes of the Palace of the Lost City on its hilltop site overlooking shimmering lakes and planted forests of ancient baobabs.

LEFT  Towering palms are offset by glowing relief mouldings, hand-laid marble and granite. Intricate mosaic art, emulating the work of craftsmen of old, depicts African animals: all this in the Rotunda – entrance to the 'Palace'.

OPPOSITE  The 18-hole, desert-style golf course at the luxurious Lost City nudges the bushveld of the Pilanesberg National Park. The 55-hectare course, boasting superb fairways and remarkable surrounding scenery, is the second at the resort. Each hole offers four tee-off points, which makes for a course length ranging from 5 400 to 6 900 metres.

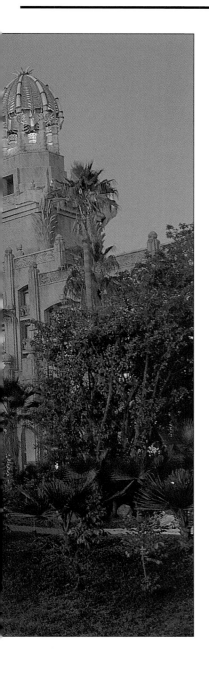

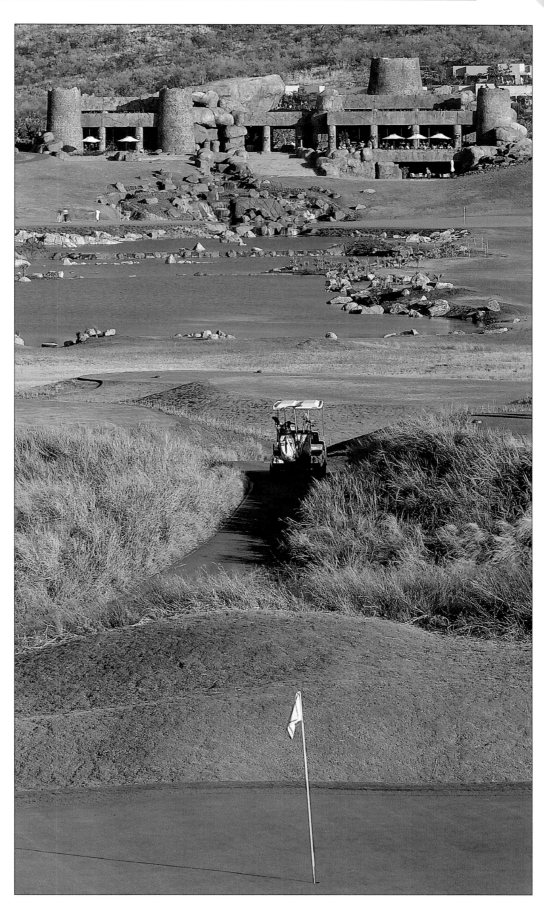

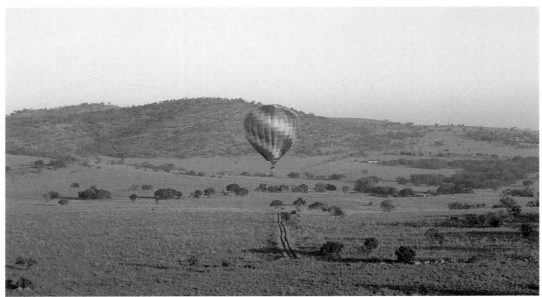

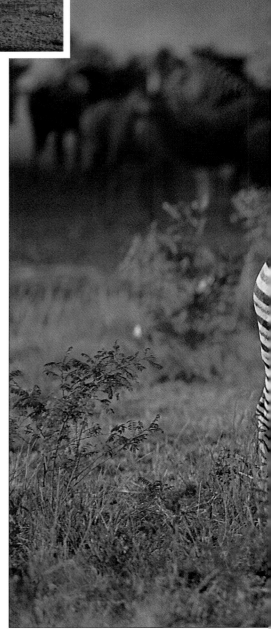

ABOVE The wonders of the Pilanes-berg, set in the centre of an aeons-old volcanic bowl, are best appreciated from the elevation of a hot-air balloon.

BELOW One of the five camps in the Pilanesberg, Tshukudu in the south-west, guarantees the safari experience will not be arduous. It was recently upgraded to a high standard of luxury. Manyane is a five-star caravan park and boasts a fine restaurant specializing in game dishes.

RIGHT North of Sun City, the Pilanesberg National Park is the result of an adventurous game-stocking drive. Its animals now number 10 000. Giraffe were among the many varieties of game introduced to Pilanesberg in the bold 'Operation Genesis' programme initiated in 1979. Other game here includes black rhino, elephant, buffalo, cheetah, leopard, zebra, eland, waterbuck and numerous other antelope.

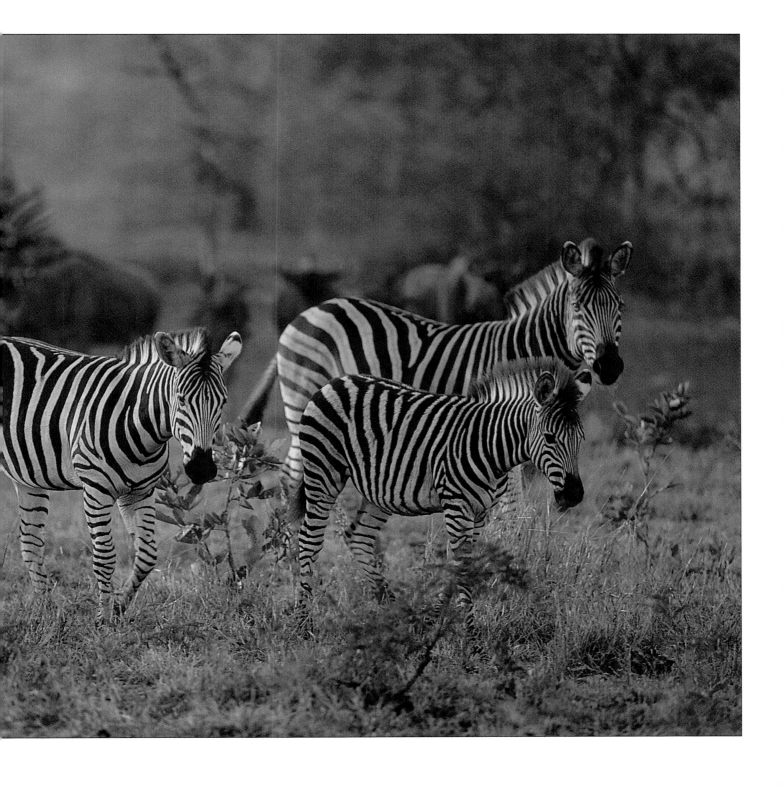

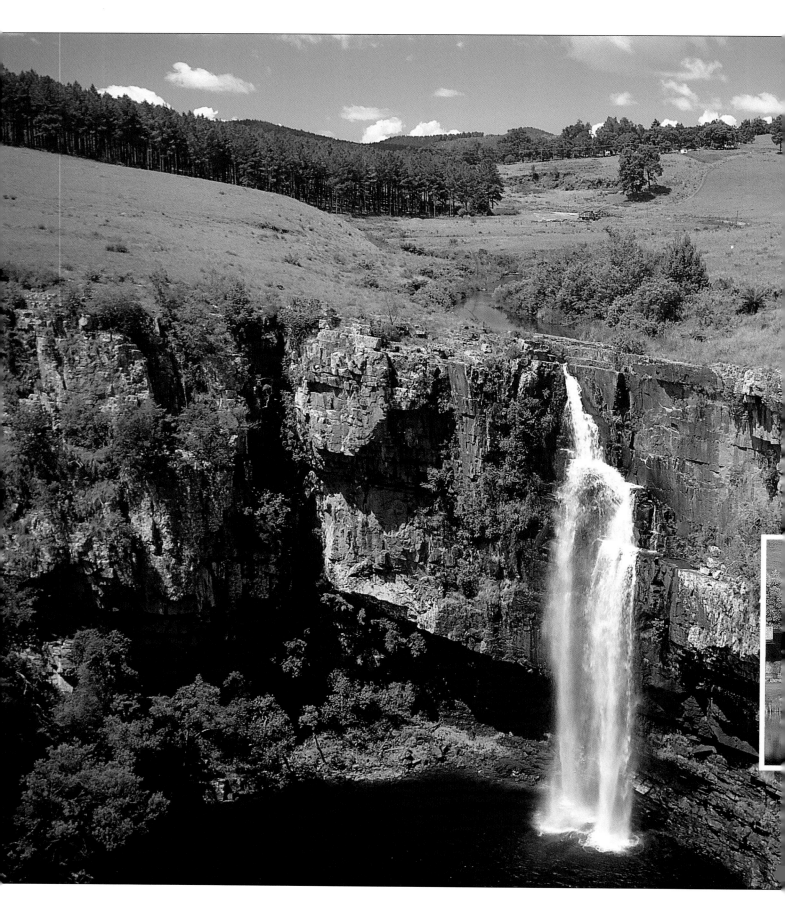

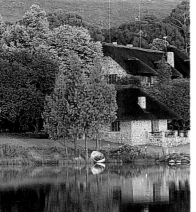

# MPUMALANGA AND NORTHERN PROVINCE

*Looking through God's window*

JUST A SHORT DRIVE, but worlds removed from the jostle of busy Johannesburg, Mpumalanga unfurls into endless golden grasslands lying tranquil under high, wide sky. North and east of this Highveld plateau, the land rises towards the cool uplands of the Drakensberg range and a dramatic escarpment which drops 1 000 metres to a low-lying, subtropical region of extraordinary fertility and lushness. This is the Lowveld, showcase of scenic splendours unequalled anywhere else in South Africa, and an irresistible lure for tourists bent on big game viewing. Animals abound in the shelter of the Lowveld sanctuaries, with the Kruger National Park and its private satellite reserves sprawled across the greatest portion of the region.

A tourist could happily lose a few weeks here, where rivers have gouged gorges through the rocks, waterfalls tumble hundreds of metres into misty pools below, trout shelter in streams and evergreen forests proliferate in the sheltered valleys and the mild climate ensures abundant crops of fruit, nuts and flowers.

This is the 'real Africa' – a land of gold prospectors and big game hunters. Reminders of their hard-won and brief prosperity before the discovery of gold on the Reef are scattered throughout the Lowveld; Pilgrim's Rest, a living replica of a nineteenth-century gold mining town; Sabie, where vast plantations flourish, planted to supply pit-props for the mines; and Barberton, where the four-legged hero of Sir Percy Fitzpatrick's bush adventure *(Jock of the Bushveld)* lived with his master for many years – all bear testimony to South Africa's hardy pioneers.

The natural treasures of the central escarpment are protected within the 22 500-hectare Blyde River Canyon Nature Reserve, with a spectacular 30-kilometre canyon, a prime attraction. For the best views, hike it; trails start with a manageable two-day walk beginning at the southernmost tip of the reserve, where God's Window, a memorable viewsite, is always open onto the unending Lowveld vista spread out 1 000 metres below. The reserve shelters a large variety of contrasting plant communities, animals and birds, including black eagles and other raptors.

FAR LEFT  The Berlin Falls near Graskop, one of many such features that grace the Lowveld Escarpment.

LEFT AND ABOVE  Trout fishermen have a choice of luxurious riverside resorts, such as Walkerson's Trout Fishing Resort near Dullstroom, from which to indulge their sport.

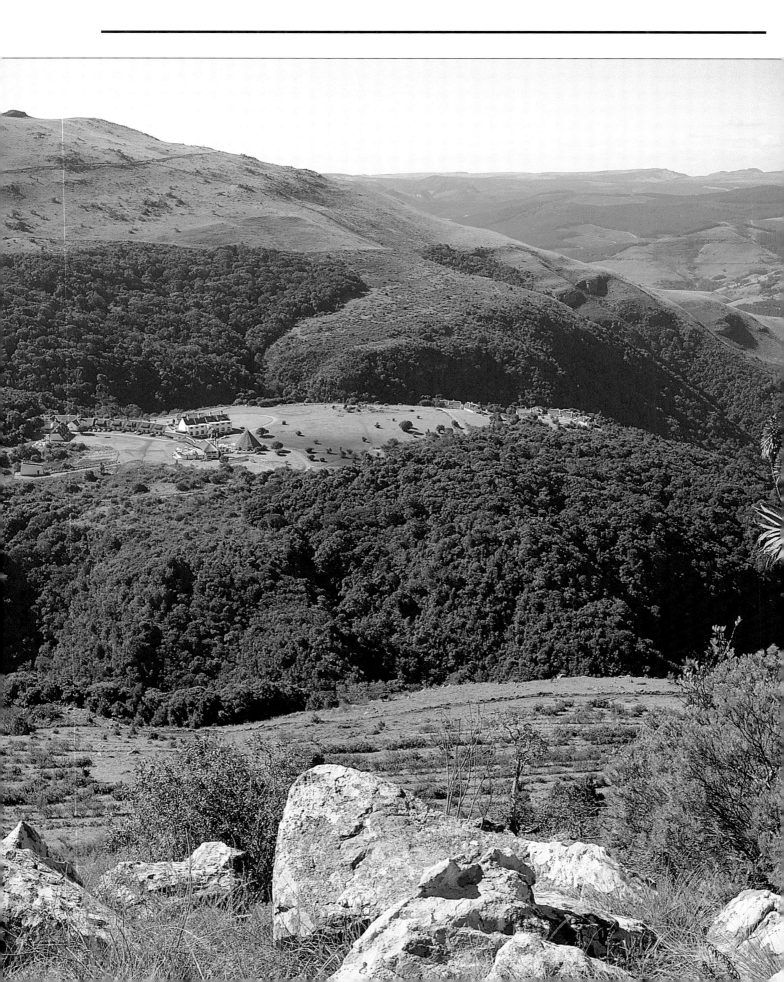

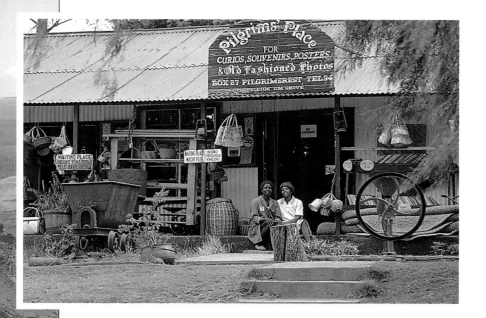

FAR LEFT  One of Mpumalanga's most famous holiday hotels enjoys a spectacular mountain location at Mount Sheba from which it takes its name.

LEFT  The little general dealer's store at Pilgrim's Rest is much the same as it was 100 years ago when it began operating.

BELOW  The tiny museum town of Pilgrim's Rest basks in early morning sunlight. Once a prosperous gold prospecting town, Pilgrim's Rest remains the only reminder of the many settlements that sprung up around the rich alluvial gold deposits which lured fortune-seekers to the area in the late nineteenth century.

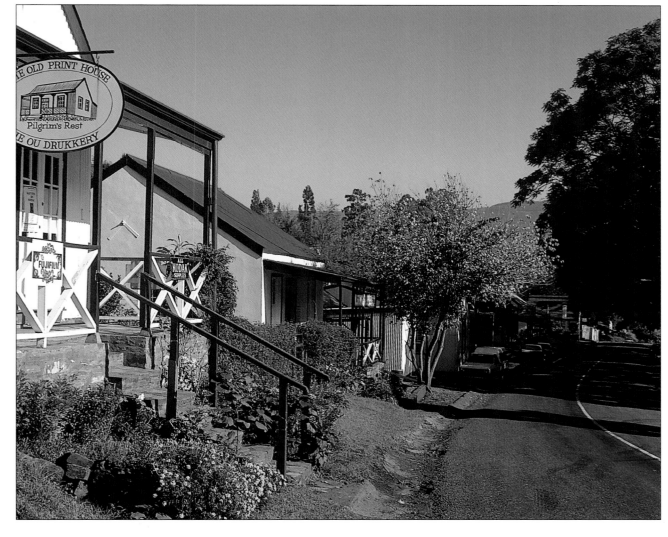

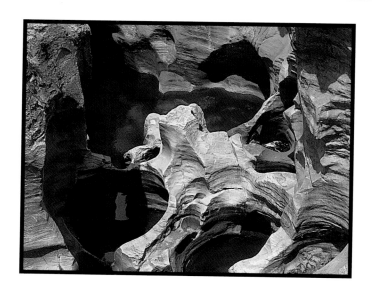

ABOVE  The extraordinary Bourke's
Luck potholes in the Blyde River Canyon,
formed by the corrosive effects of water
and rushing boulders.

BELOW  Hikers pausing to admire
the view in the restful sanctuary of the
Blyde River Canyon Nature Reserve.

OPPOSITE  The awesome spectacle
of a massive gorge, part of the glorious
scenery of the Blyde River Canyon.

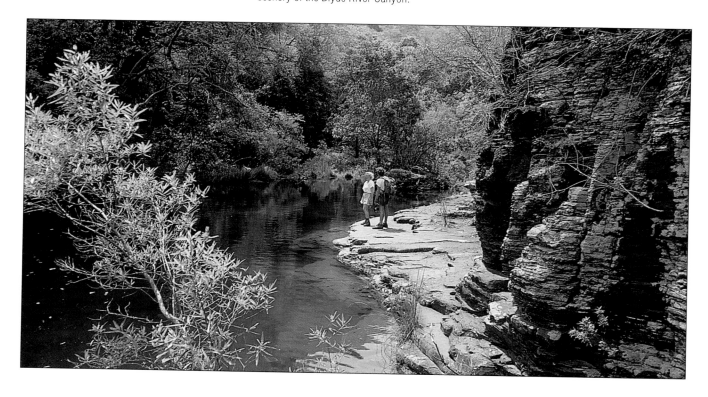

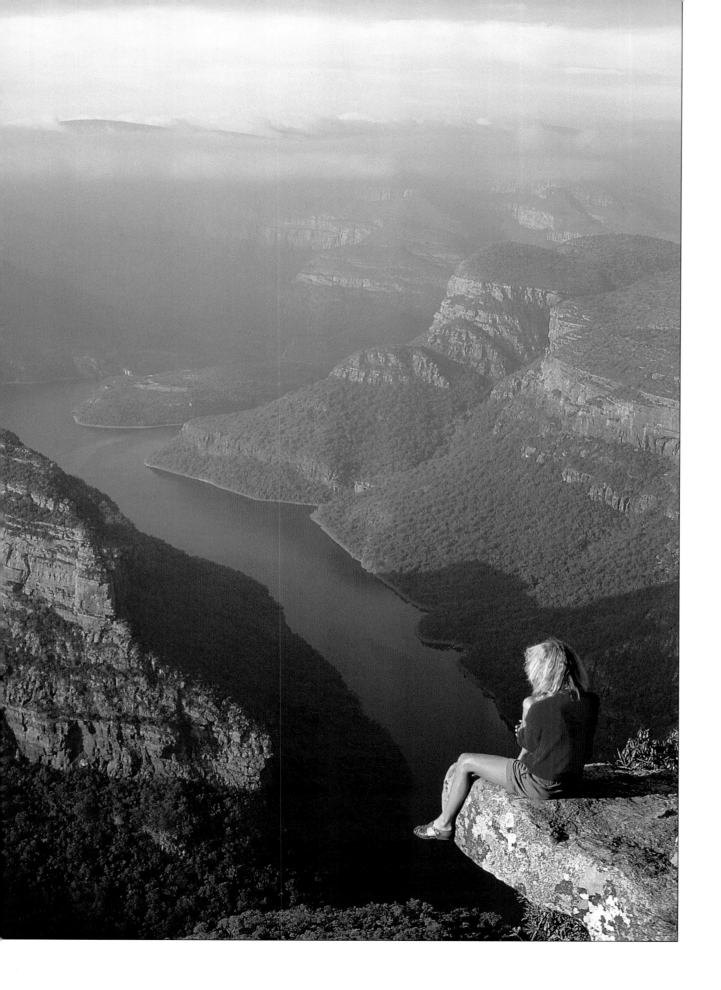

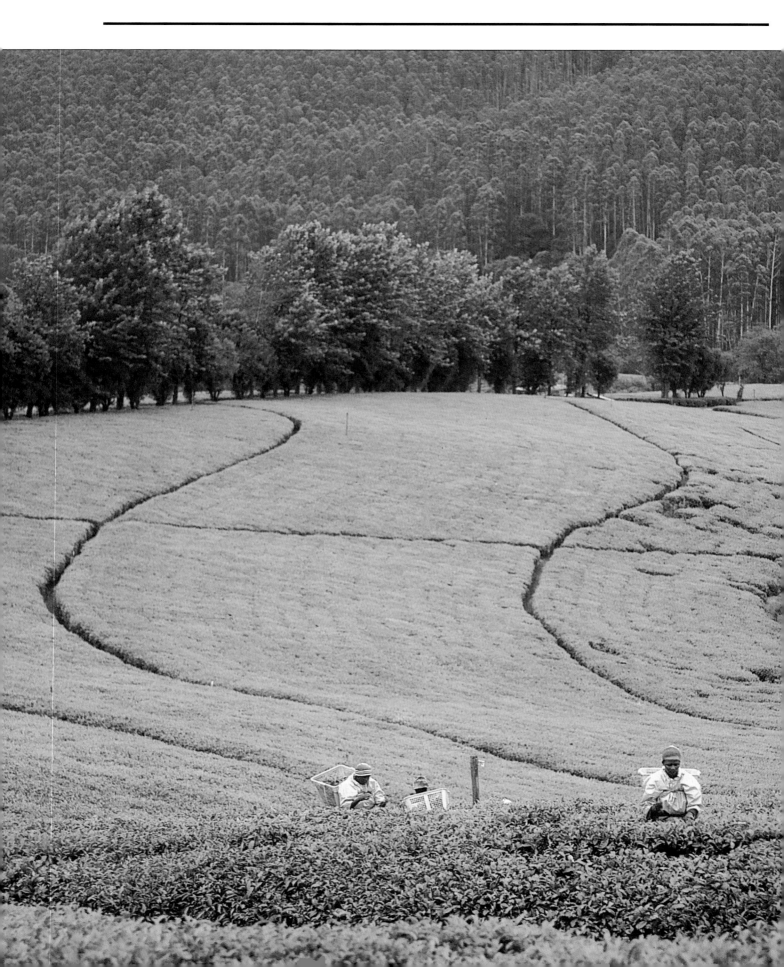

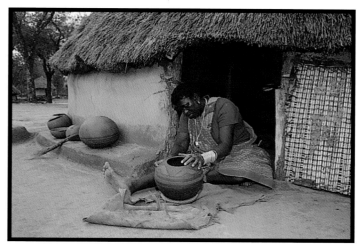

LEFT  Sprawling tea plantations blanket the hills near Tzaneen. The subtropical climate of this north-eastern region of South Africa accounts for a wealth of other exotic produce grown here, including pawpaws, mangoes, litchis, bananas and avocados.

ABOVE  A Tsonga woman decorates a clay vessel at a representative Tsonga village, which is part of the open-air museum in the Hans Merensky Nature Reserve.

BELOW  Venda women colourfully attired in traditional garb.

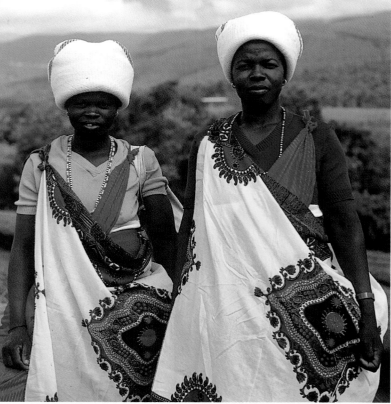

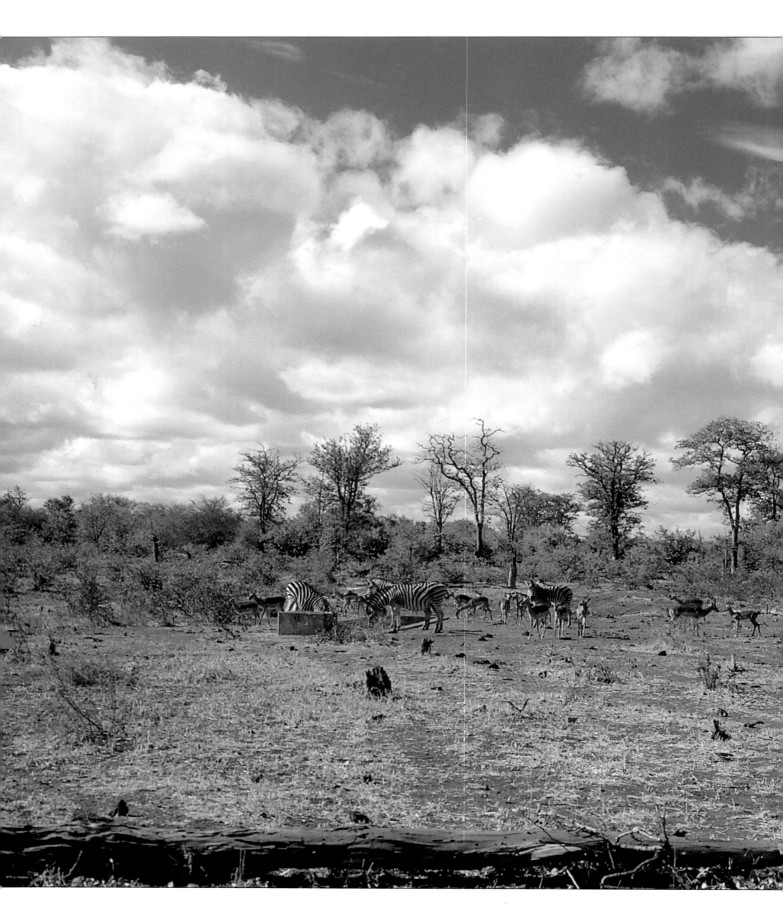

# THE KRUGER

*Pride of national parks*

THE KRUGER NATIONAL PARK, Africa's oldest and one of the world's most famous wildlife sanctuaries, is internationally acclaimed for its model management which successfully uses tourism to fund conservation; in short, it is a model of ecological tourism.

The park occupies almost two million hectares of the Lowveld where even an average of 5 000 visitors a day cannot spell overcrowding. Many are daytrippers, others spend two or three nights in one of the park's numerous well-equipped and affordable rest camps. Its western boundary is flanked by private reserves with luxury camps – among the most expensive travel destinations in South Africa providing glamorous bush accommodation. Whatever their differences, the objectives are common: to put tourist revenue back into conservation for future generations.

The 'Big Five' – elephant, lion, leopard, rhino and buffalo – are a major drawcard at the Kruger National Park; at last count there were 7 600 elephant, 2 000 lion, 1 000 leopard, 1 800 white rhino and a staggering 21 880 buffalo. With numbers like these it is hard to miss taking home a photographic trophy and few tourists go away disappointed.

Covering a vast land area, the park offers a number of differing ecosystems and landscapes to which various species naturally gravitate; these include the densely vegetated banks of five rivers flowing across it from west to east. The wooded south-western regions are favoured by rhino and buffalo, while the grassy cover interspersed with acacia in the south-east supports impala, zebra, wildebeest, giraffe and black rhino – and, because of the antelope population, attracts predators. Elephant territory is north of the Olifants River, which dissects the park laterally through the centre. Here too are eland and roan and sable antelope, which, like the elephant, feed off the turpentine-smelling mopane tree. The far northern reaches are perhaps the most ecologically interesting, being the meeting place of nine major ecosystems supporting a remarkable density and variety of animals, reptiles and insects.

Game-viewing in the Kruger National Park is best in winter when the vegetation cover is sparse and animals tend to converge in great numbers along the river banks and artificial watering holes. But it is in summer that the bush truly comes to life with fresh, green growth, exuberant young creatures and a myriad birds.

LEFT  One of the world's greatest and most renowned game sanctuaries, the Kruger National Park is a sprawling and pristine wilderness, home to the 'Big Five' and innumerable other species of fauna and flora spread across its several ecosystems.

ABOVE  The evergreen Olifants River Valley viewed from the elevation of a cliffside rest camp. Public rest camps within the Kruger Park are restful places, all of them fenced off and attractively laid out to include spacious lawns, trees and flowering plants.

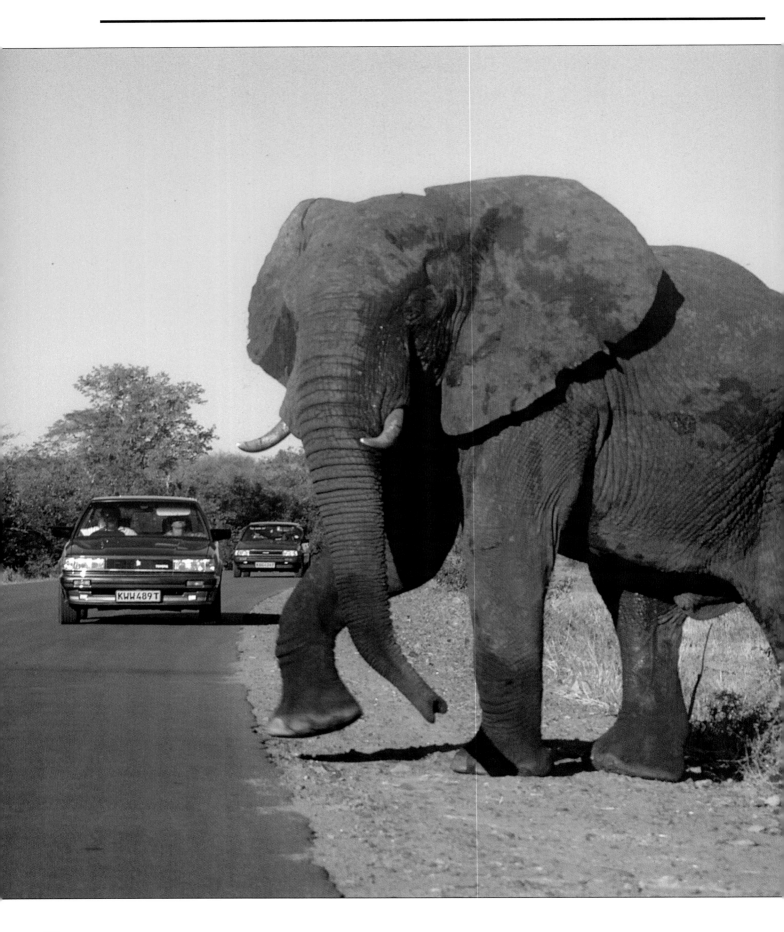

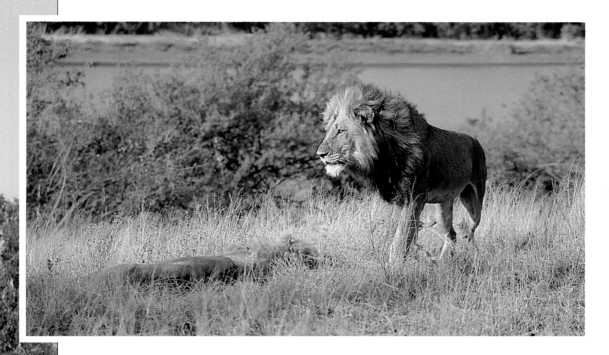

LEFT Elephant *(Loxodonta africana)* are constantly on the move to find food and water. An African bull of 6,5 tonnes can eat 250 kilograms a day.

ABOVE A mature male lion *(Panthera leo)* stands alongside a female. Lions are territorial, defending a home range of anything from 20 to 400 square kilometres. Most of the hunting is done by the females, although the males are first to eat. Lions spend most of the day sunning, grooming and sleeping, hunting in the cooler hours.

RIGHT A herd of elephant fording the Olifants River, one of six permanent waterways flowing through the area. To the north is elephant country, also grazed by tsessebe, eland, and roan and sable antelope, which feed off the predominant mopane woodland. To the south, grazing is plentiful, and the land supports zebra, wildebeest, giraffe, black rhino, impala and lions.

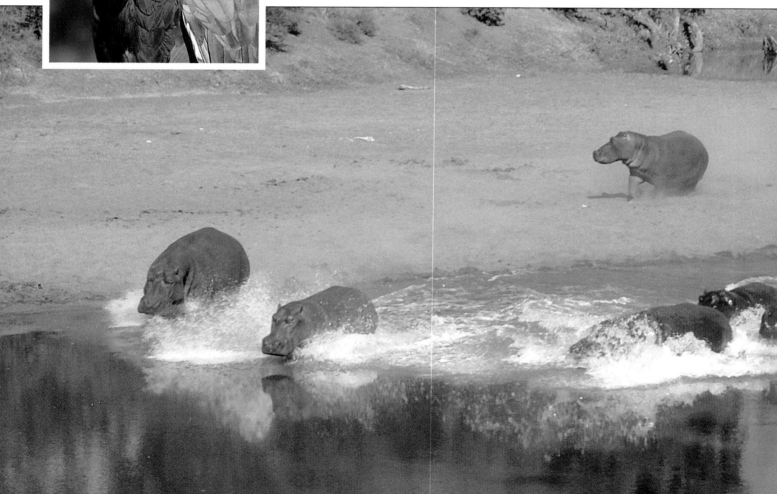

OPPOSITE TOP LEFT The bateleur eagle *(Terathopius ecaudatus)* and several other raptors can best be viewed from the bushveld camp bearing the bird's name. Fifteen of South Africa's 17 eagle species are found in the park, including the martial and African fish eagles. It boasts 50 different species of birds, including five vulture species. Up to 80 different species can be seen in a day at some camps.

OPPOSITE TOP RIGHT Under the guidance of experienced rangers, visitors can join one of the exciting wilderness trails through the park. For those wanting a more immediate experience of wildlife, these foot safaris are undertaken in areas of unspoilt beauty, inaccessible to any vehicles.

BELOW Hippos *(Hippopotamus amphibius)* near Pafuri Gate, the northernmost entrance to the Kruger

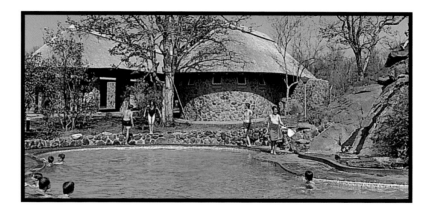

National Park. These usually placid creatures can be dangerous when provoked. Visitors are advised to adhere to the safety regulations issued at each of the park's entrances. Open vehicles and motorcycles are not permitted.

ABOVE Rough stone and thatch have been used in the construction of many of the park's public camps so as to intrude as little

as possible on the bushveld. The Kruger offers a wide variety of visitor accommodation, from the fairly basic to the sophisticated and luxurious. Mopani Rest Camp, shown here, offers a small conference centre and, as seen, a sparkling swimming pool. Other accommodation facilities include caravan and camp sites, and several rest camps equipped for disabled visitors.

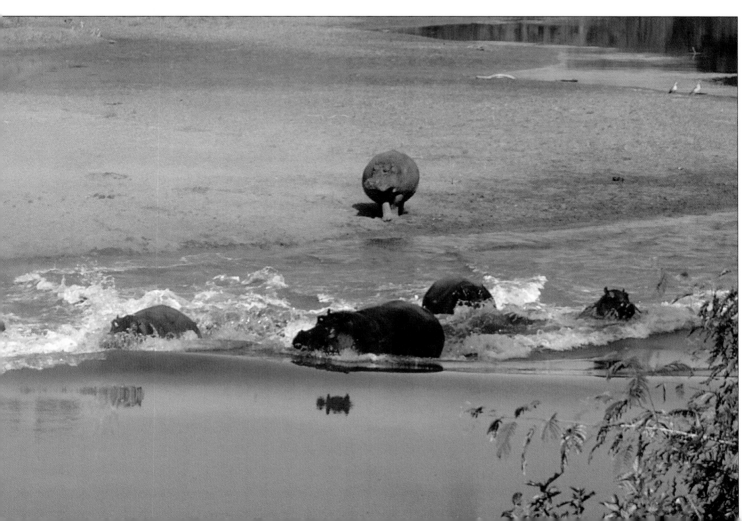

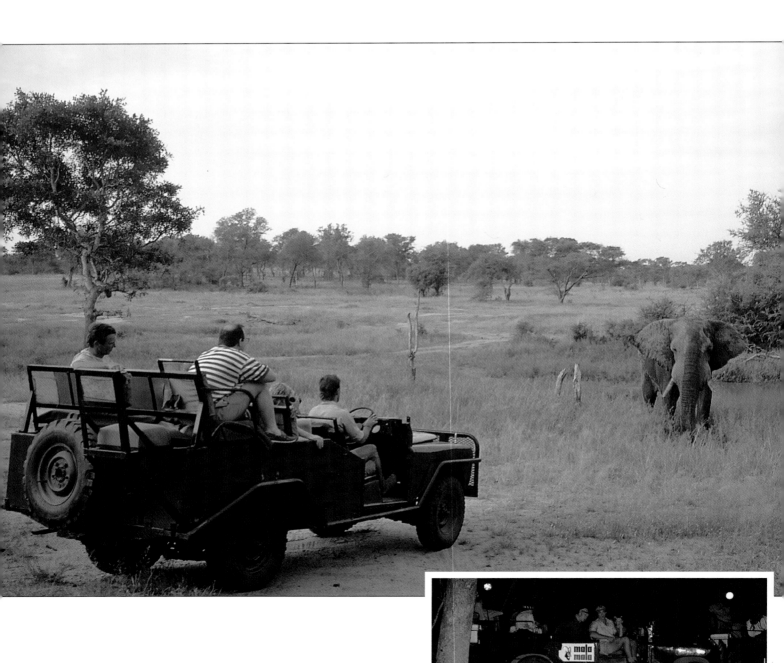

ABOVE  The leopard (Panthera pardus) spends the great majority of its time resting in the upper branches of a tree. It is a solitary creature and hunts mostly at night, often dragging its prey on to a high branch in order to avoid competition from other predators such as lions.

BELOW  South Africa's prime private reserves provide the utmost in luxurious safari experiences. Many of these exclusive retreats are dotted along the western boundary of the Kruger. South Africa's private reserves offer exceptional game-viewing, luxurious accommodation, fine cuisine and, all-round, a superb bush experience.

ABOVE AND BOTTOM OPPOSITE  Day and night game-viewing drives in the Kruger National Park and nearby private reserves, in the company of qualified guides and rangers, allow for game-viewing at close quarters, offering visitors a more intimate experience of the bushveld than they would otherwise have had.

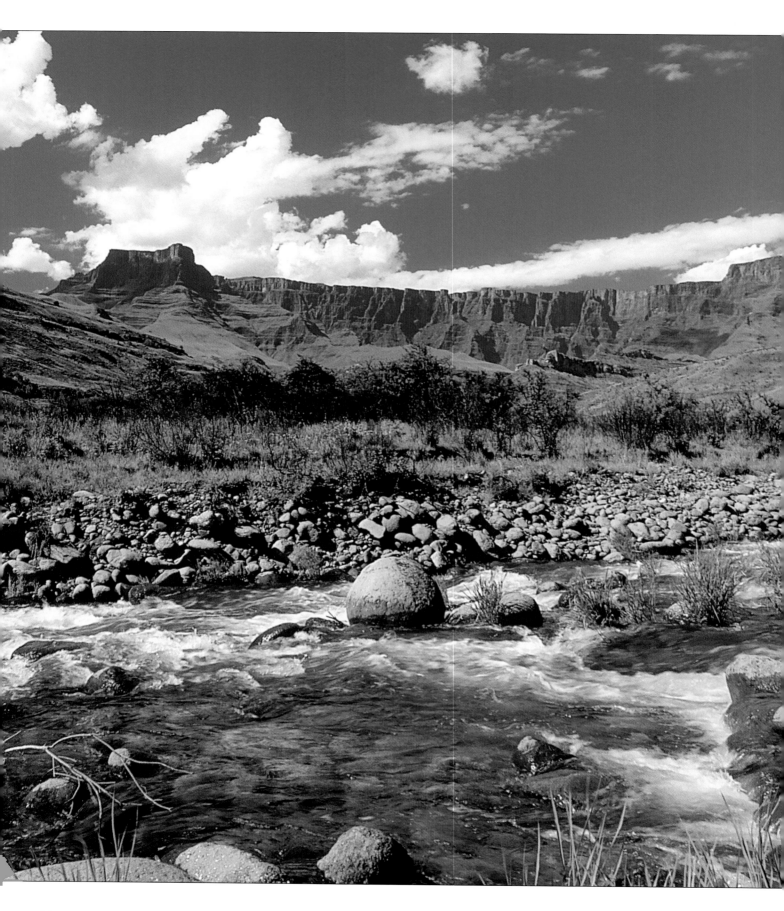

# THE GREAT ESCARPMENT

*Heading for the hills*

THE MOST SPECTACULAR OF all South Africa's many mountain territories are those which cleave into the Free State (formerly known as the 'Orange Free State') and KwaZulu-Natal – the Maluti and KwaZulu-Natal Drakensberg mountain ranges, which are set in the centre of the Great Escarpment, cupping the country in a rugged horseshoe. It is to these serene and isolated regions that travellers come for release from their urban woes, to walk, climb, fish, ride or simply recharge their batteries in any one of a host of luxurious log chalets tucked into the foothills of the formidable mountains.

Rising to 3 000 metres in places, the Drakensberg's oceanside face features soaring buttresses, pinnacles, natural amphitheatres and serried rows of rocky 'spears', which provide dramatic viewing. Their highest peaks are blanketed by heavy snowfalls in winter, imparting an Alpine air to this part of sunny South Africa.

In the warmer months of the year the sunlit silences are broken only by the calls of the masters of the sky – the majestic raptors, including vultures, eagles and the endangered bearded vulture (lammergeier) – and by the tiny sounds of numerous animals: antelope, mountain tortoises and ice rats (of the family *otomys*), going about their peaceful business. The Royal Natal National Park, which sprawls across 8 000 hectares of the high 'Berg', incorporates some of the mountains' most stirring sights.

In the south-eastern corner of the Free State, where the interior plateau meets the Maluti Mountains, stands a massive sandstone portal, the Golden Gate, which gives entry to the wonderfully scenic Golden Gate Highlands National Park. This sanctuary provides safety for a variety of game: grey rhebok, oribi, springbok, black wildebeest, blesbok, eland and buffalo. Bird life too is well represented in this area of the country, comprising more than 150 species which include the bearded vulture and black eagle. The many trails available, either on foot or on horseback, can be as brisk or as leisurely as you please. Accommodation is available in comfortable and well-appointed rest camps.

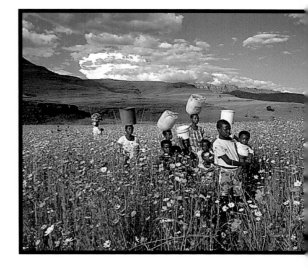

LEFT The breathtaking Amphitheatre, a natural formation of stone rising in parts to 3 000 metres above sea level, is one of the Berg's most imposing features. Seen from within the great boundaries of the Royal Natal National Park, the Amphitheatre embraces the enduring drama of Nature, in all her acts of turbulence and, here, serenity. ABOVE Wading through a field of cosmos, a small party of women and children carry water home in an assortment of vessels.

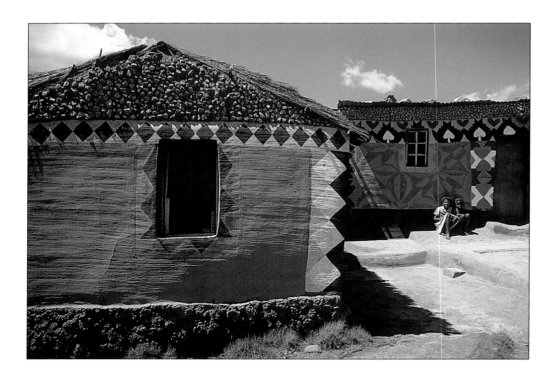

ABOVE Both brilliant and subtle, a cluster of Sotho huts, embellished with graphics that are done by the women of the tribe.

BELOW Hardy sunflowers outface the blazing Free State sunshine.

RIGHT A Basotho farm hand in traditional blanket and woven hat tends his charges on a Clarens farm, at the foot of the blue Malutis in the Eastern Highlands of the Free State.

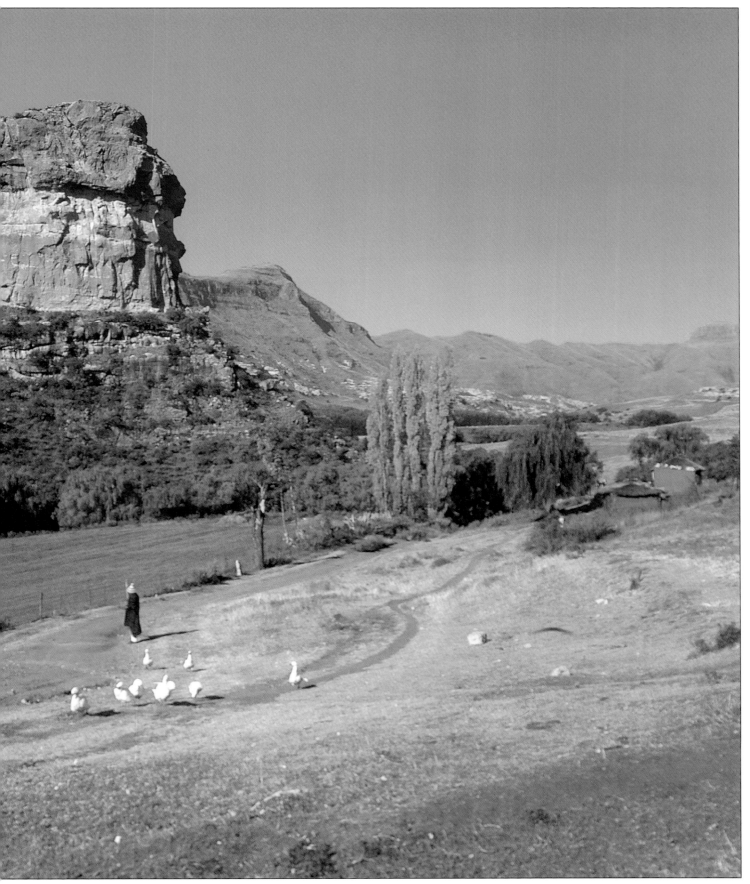

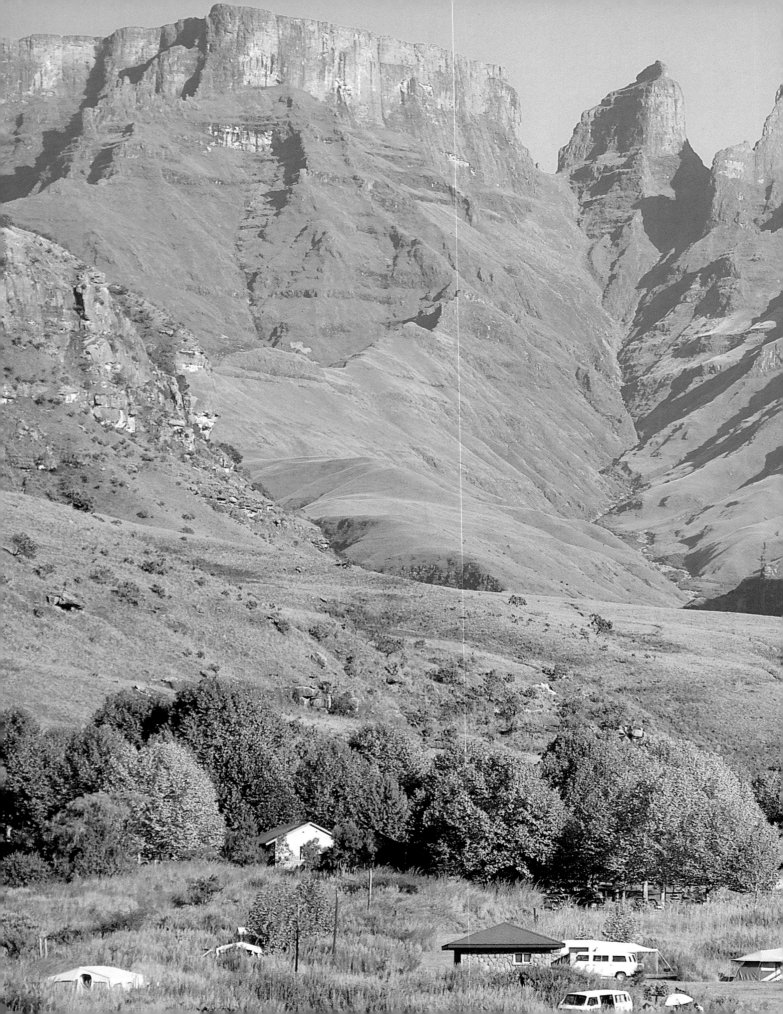

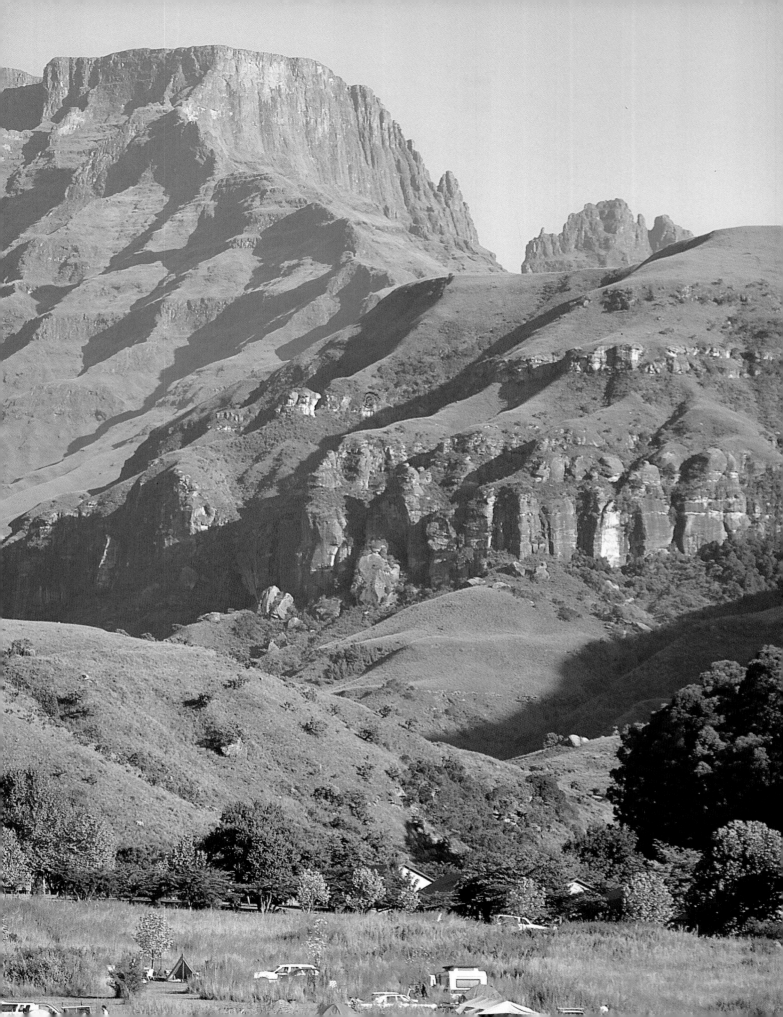

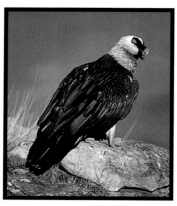

among them the rare bearded vulture or lammergeier *(Gypaetus barbatus).*
BELOW  Only the San rock art reminds us that the Drakensberg was the last haven for the San people. These eland and figures are preserved in the Game Pass Shelter of KwaZulu-Natal's Kamberg Nature Reserve.

BOTTOM  Pony trekking is offered by the Natal Parks Board in the Royal Natal National Park.
OPPOSITE  Hikers pause above a precipitous drop at the top of the Amphi-theatre to enjoy a view of the Eastern Buttress and Devil's Tooth, one of the best-known sights in the Berg, ahead.

PREVIOUS PAGES  A waterfall gushes down a cleft in the escarpment above the Injasuti caravan park and camp site. The Injasuti Dome, more than 3 400 metres above sea level, is one of the highest points in South Africa.
ABOVE  The Drakensberg, with its cliffs, gorges and rugged landscapes, is an ideal habitat for a variety of raptors,

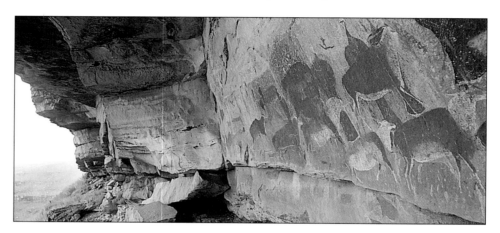

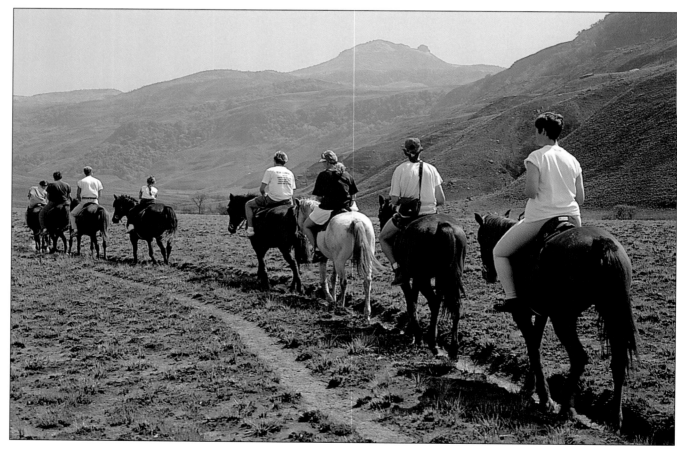

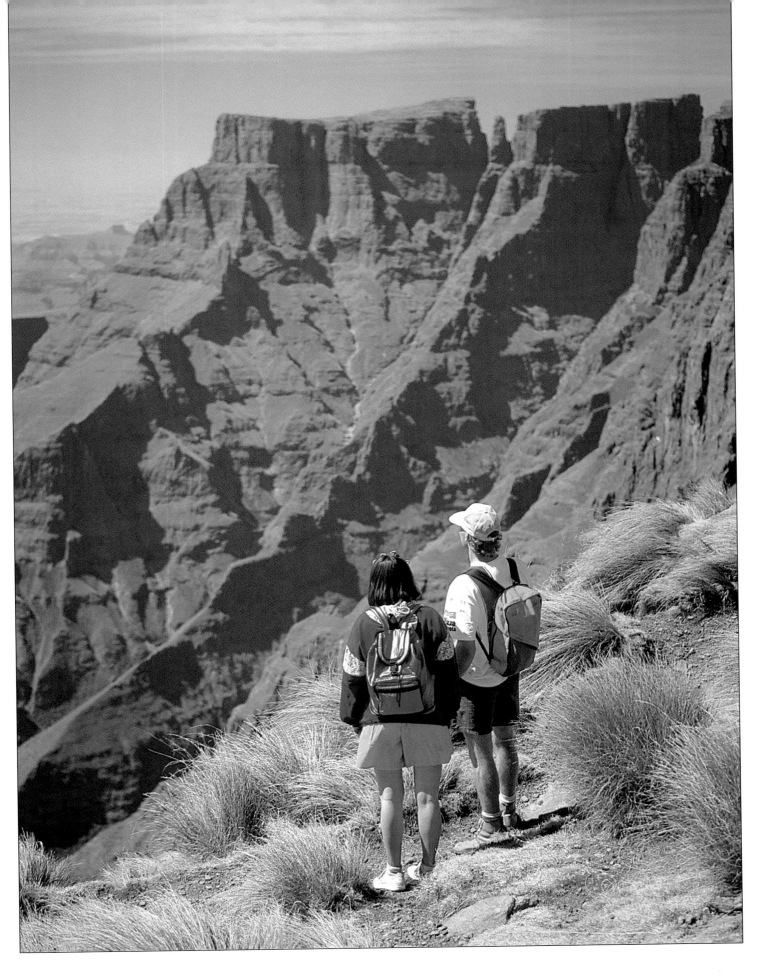

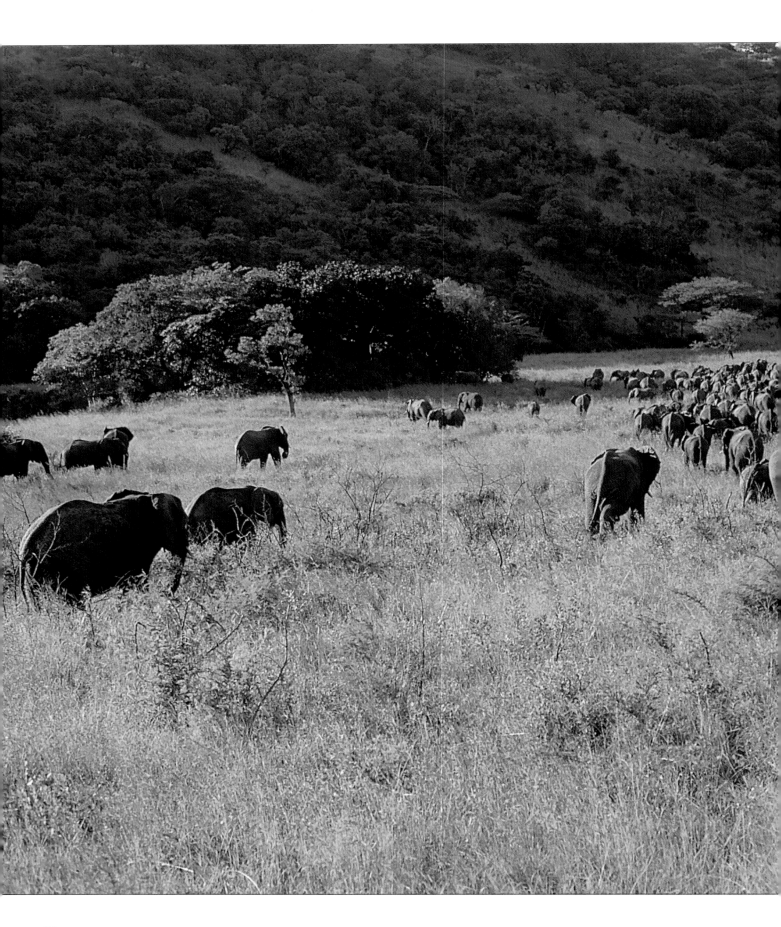

# KWAZULU-NATAL

*Birthplace of parks*

**W**HAT IT LACKS IN size it makes for up in stature: KwaZulu-Natal has a remarkable 32 game parks and nature reserves all contained within an area that constitutes only eight per cent of the country's total land area. Its 570-kilometre shoreline is laced with two thirds of the nation's estuaries, creating specialized wetland and marine habitats for flora and fauna found nowhere else in South Africa. Its diverse ecosystems range from forest to grassland, bushveld to thornveld, coastal dune forests, swamp- and marshlands, to coral reefs.

In Maputaland, along the northern coast, where the tropical and subtropical zones meet, lies one of the world's most significant wilderness areas – the Greater St Lucia Wetland Park, composed of a cluster of parks and reserves along the coast as far as Kosi Bay. The estuarine systems and towering dunes, coral reefs and stands of mangrove swamps support a myriad animals, birds, flora and marine organisms. Hippo and crocodile bask on the banks; the water is warm – up to 30° C in the shallows – and very blue; and, at night, giant leatherback and loggerhead turtles swarm on to the beaches to lay their eggs in nests of sand.

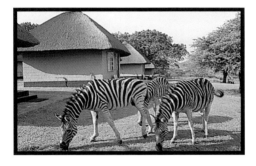

KwaZulu-Natal has a long history of conservation. It was at Umfolozi and Hluhluwe (now managed as one park by the Natal Parks Board) that the first land was set aside for animal protection in 1895, three years before the birth of the Sabie Reserve – later to become the Kruger National Park. Umfolozi is renowned for its population of black and white rhino, rescued from extinction in a campaign spearheaded by conservationist Ian Player. Some areas within the Hluhluwe-Umfolozi Park, including a 24 000-hectare wilderness in the Umfolozi section, can only be traversed on foot; hikers have the option of using pack donkeys to cart luggage to bush camps, or they can carry it themselves and sleep under the stars. Both the Umfolozi and Hluhluwe sections have hutted camps, lodges and bush camps. This park is set in surroundings of extraordinary beauty, and visitors are likely to want to spend several days savouring all that is on offer here.

Among a host of other private and provincial reserves is the Itala Game Reserve, pride of the Natal Parks Board, with more than 70 species of mammals protected within its boundaries. One of the more out-of-the-way reserves, Itala offers trails and day walks, and caters for safaris in style at its new, sophisticated Ntshondwe Rest Camp.

LEFT African elephant are among the 84 mammal species found in the Hluhluwe section of KwaZulu-Natal's Hluhluwe-Umfolozi Park. The elephant, a gregarious animal, moves in closely knit herds comprising on average about 20 members. At the head of the herd is a matriarch or female leader, usually the oldest cow, who presides over the other members: her sisters, daughters and their young.

ABOVE Zebras find convenient grazing at the Mpila hutted camp in Umfolozi.

RIGHT Guided wilderness trails lasting five days are organized by the Natal Parks Board from March to October. Daily sorties into the bush are followed by convivial evenings around the camp fire.

BELOW The adult giraffe *(Giraffa camelopardalis)* towers six metres above the ground. Although extremely swift and naturally camouflaged by its dappled coat, the giraffe is vulnerable to attacks (particularly by lions) when drinking at water holes.

BOTTOM The restaurant complex at Ntshondwe – rated as the country's finest public rest camp – occupies a spectacular site in Itala. Eighty mammal species find suitable habitat in the reserve's 30 000 hectares of cliffs and forested slopes, grassland, bushveld, savanna and amid the numerous watercourses lined with lush riverine forests.

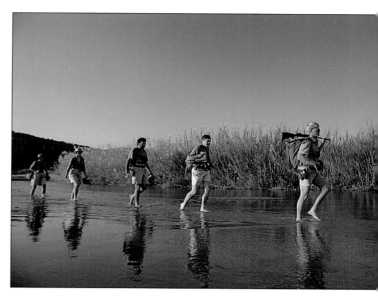

OPPOSITE The white rhino, which is bigger but less aggressive than its relative, the black rhino, was brought from the brink of extinction, specifically by efforts in the Umfolozi section of the Hluhluwe-Umfolozi Park to protect the once dwindling population.

In an attempt to curb extensive rhino poaching today, conservationists have frequently had to resort to dehorning the animals. Of Africa's surviving population of about 3 500 rhinos, some 400 are found in the parks of KwaZulu-Natal.

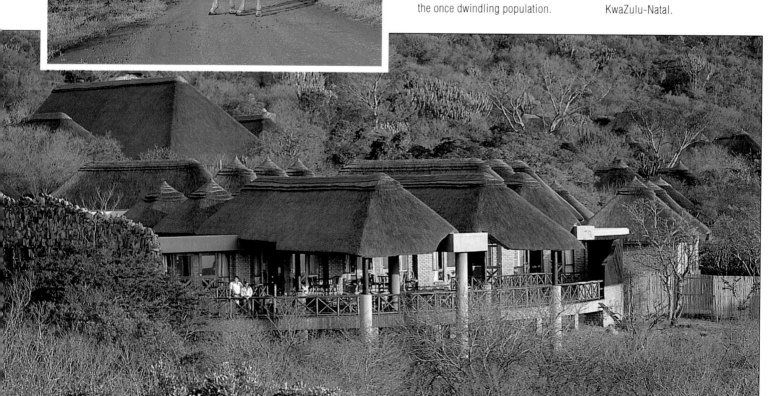

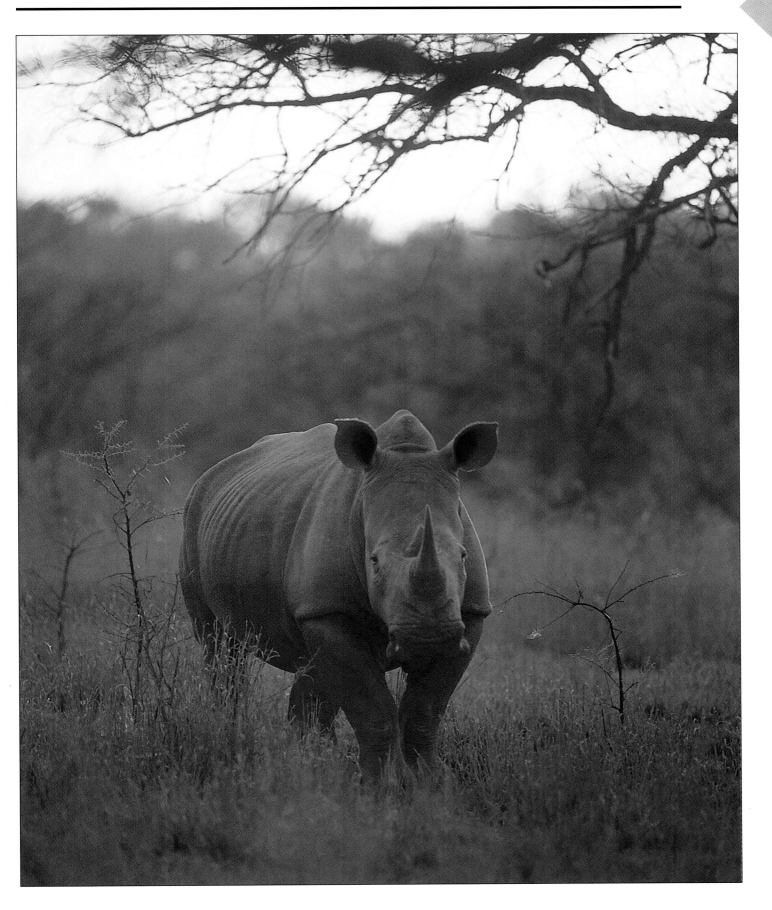

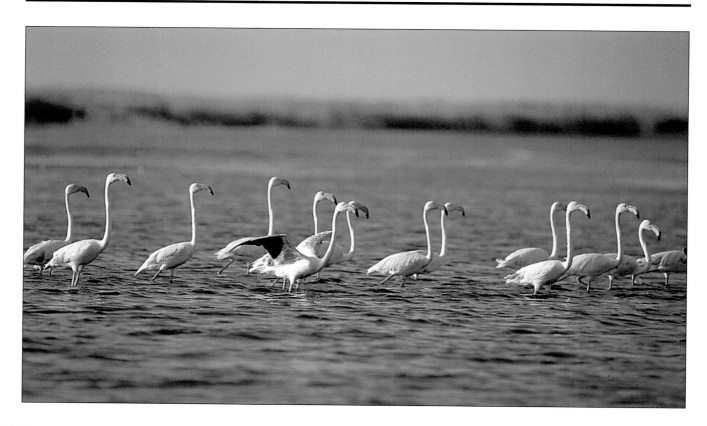

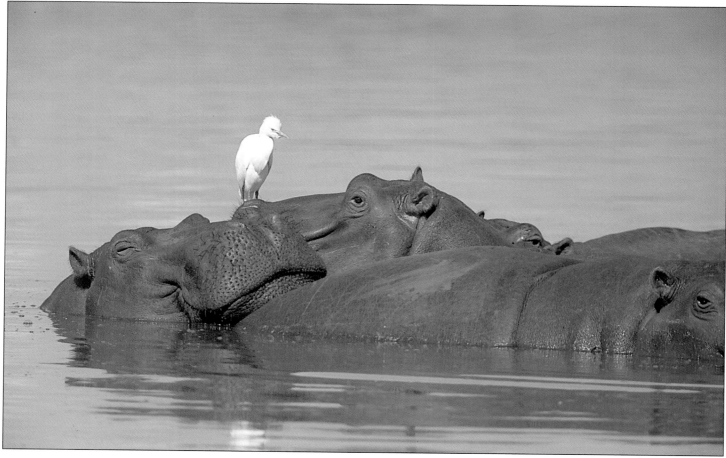

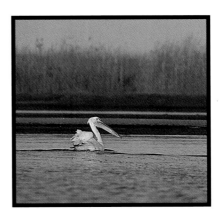

TOP OPPOSITE Flamingos proliferate in shallow lakes and salt pans throughout southern Africa. The smaller and pinker lesser flamingo is exclusively a filter feeder while the greater flamingo, here seen feeding in Lake St Lucia, supplements its diet with small organisms from the muddy floor.

BOTTOM OPPOSITE Hippo spend the greater part of their day submerged in the water. However, they leave the water at night, and follow fixed pathways to grazing grounds. In this scene, a lone egret is caught resting on the nose of a wallowing hippo in Nsumu Pan at the Mkuzi Game Reserve. This reserve forms part of the Greater St Lucia Wetland Park, which lies on the Zululand coast and is one of the most important wetland and marine wilderness areas in the world. The focal point is the shallow, 36 000-hectare expanse of water, Lake St Lucia, surrounded by wetland parks, game and marine reserves.

RIGHT Pinkbacked pelicans (Pelecanus rufescens) and other water birds have come back to Lake St Lucia since the mouth of the Hluhluwe River, one of the four rivers that feed the lake, was reopened in the 1960s. The trees of Nsumu Pan are home to the only breeding colony of pink-backed pelicans in South Africa, where about 250 breed at midsummer.

BELOW Gone fishing – in the subtropical coastal waters near St Lucia.

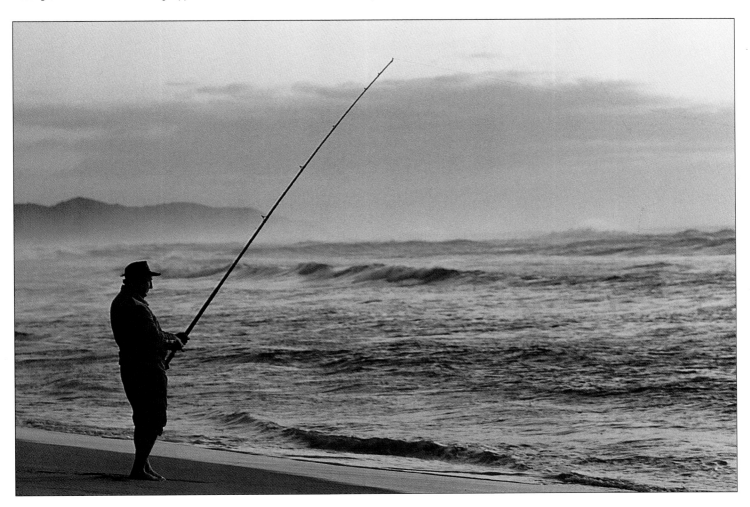

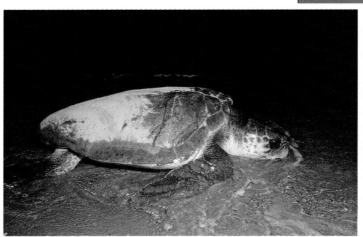

ABOVE AND ABOVE RIGHT
Snorkelling and scuba diving reveal a
rich palette of underwater sights: shoals
of jewelled fish, coral reefs and turtles
(loggerhead and leatherback) rigorously
protected within the boundaries of exten-
sive marine sanctuaries. Scores of giant
sea turtles moving onto the beaches to
lay their eggs at night is one of Maputa-
land's exceptional sights. Between
October and February, the females lay
up to 500 soft-shelled eggs, at ten-day
intervals, in well-concealed nests of sand.
Only then do they retreat to the sea.
Seventy days later the hatchlings must
brave the beaches and potential predators
to find their way to the water.

BELOW   Balmy weather and mild
water bring watersport enthusiasts to
Sodwana Bay all year round. These
waters are considered among the finest
in the world for game fishing: blue and
black marlin, tuna and sailfish are almost
commonplace trophies.

RIGHT   Sodwana Bay, meeting
place of crystal waters, gilded beaches
and swathes of coastal forest. Birds
and wildlife abounds in the forests and
lakes of the Sodwana Bay National
Park, while offshore reefs of coral invite
underwater exploration. Sodwana Bay is
situated at the northernmost tip of the
Greater St Lucia Wetland Park within
the St Lucia Marine Reserve.

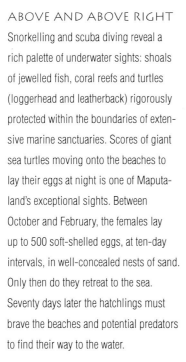

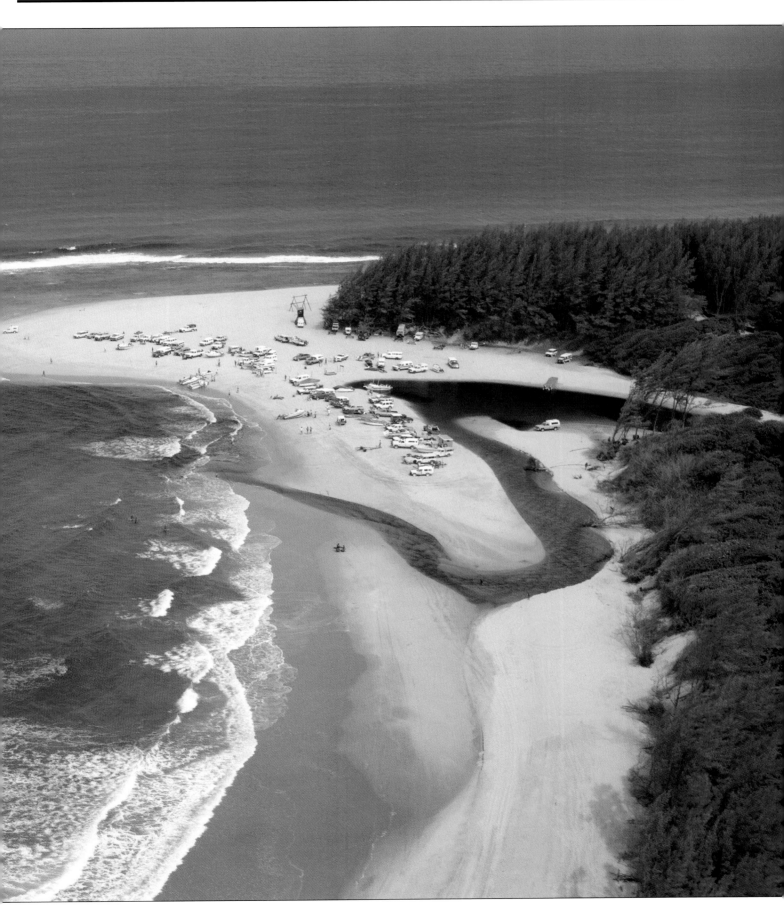

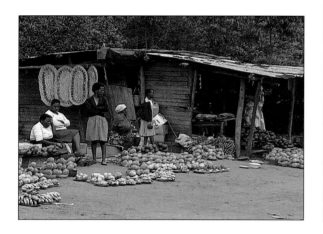

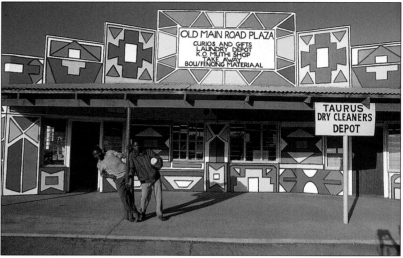

TOP LEFT A roadside stall close to Empangeni, west of Richards Bay, sells fruit and Zulu grasswork. To the north, west and south, the countryside is littered with battle sites, graves and other sorrowful reminders of the bloody clashes between Zulu, Boer and Brit, and of the great men who died in the conflicts.

ABOVE A dazzlingly decorated store at the town of Hluhluwe caters to consumer convenience, from *muti* to dry-cleaning. Zulu beadwork can be seen at various points along the Zulu cultural route, inland between Eshowe and Ulundi in the north. In the Nkwaleni Valley, just an hour-and-a-half from Durban, visitors can participate in another tribal experience at Shakaland, the site created for an epic television series, where accommodation is provided in a village of beehive huts.

BELOW Dancing is an integral part of Zulu tribal life. In this ceremonial dance display at Shakaland the men carry small ornamental shields, called *ihawu*, and painted sticks in place of the protective shields and spears of battle.

OPPOSITE Surrounded by all the ingredients used for *muti*-making, a Zulu herbalist or *nyanga* sits outside his practice in Shakaland.

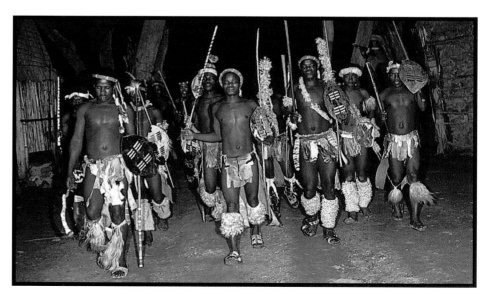

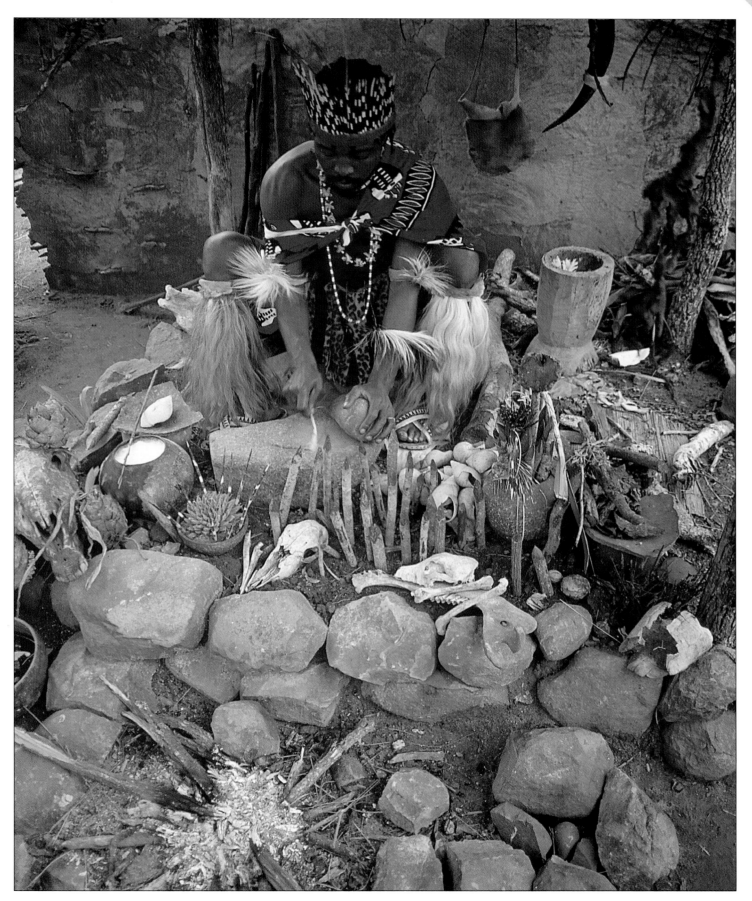

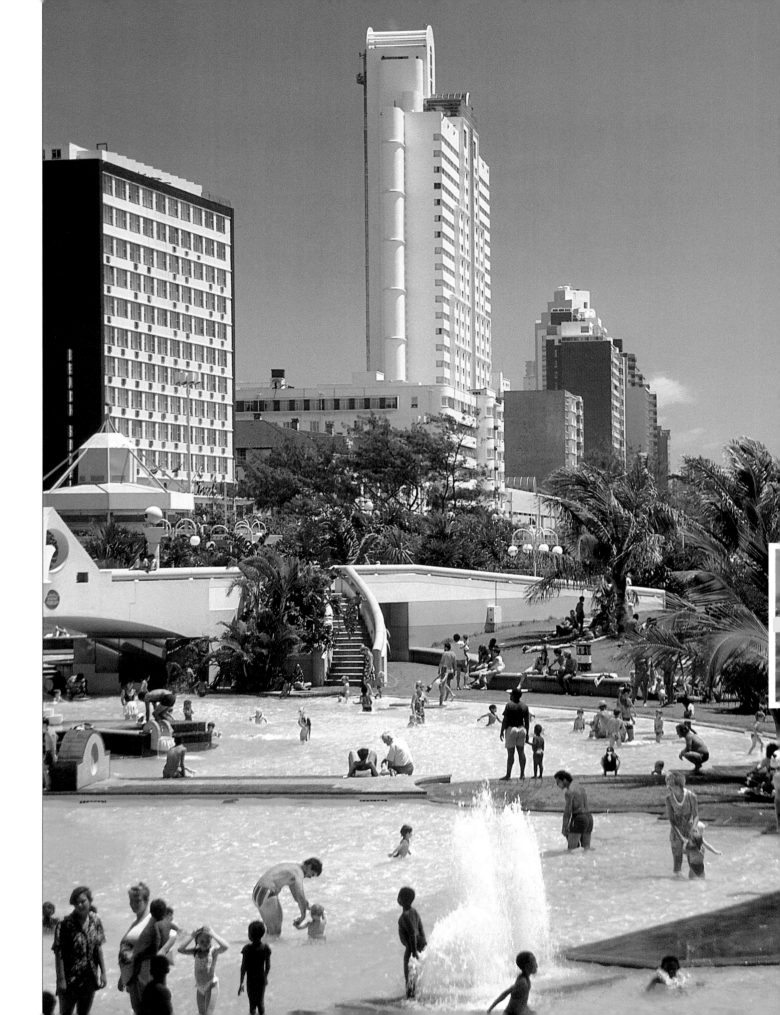

# DURBAN AND THE EAST COAST

*Sunshine city*

**T**WICE A YEAR, DURING the longest school holidays, thousands of holiday-makers from the north come to Durban in search of surf, sand and sun. Unmoved by the city's colonial architecture, botanical gardens, excellent museums and galleries, holiday hordes converge on the playgrounds, parks and promenades – and their multitudinous entertainments – in search of recreation. The hub of activity is the 'Golden Mile', a six-kilometre strip of silky, sub-tropical beaches washed by the warm Agulhas Current of the Indian Ocean.

Hotels, apartment blocks and restaurants form a backdrop to the beaches. The Marine Parade boulevard and beachfront promenade are lined with multi-hued rickshaws, craft stalls, an amusement park with chairlift rides, and booths offering surfboards, bicycles and paragliders for hire. There is an aquarium and dolphinarium with performing dolphins and seals at Seaworld; snakes and crocodiles at the Fitzsimons Snake Park; and talent and beauty contests held all summer at the Little Top, an *al fresco* theatre on South Beach.

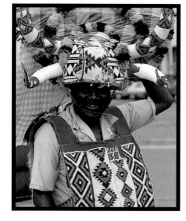

Durban's million-strong Indian population concentrates its commercial affairs on the western side of the city. This is where shoppers should go for exotic shopping and exciting cuisine among the mosques and market places.

Upmarket resorts hug the Dolphin Coast en route to the northern reaches of the province, where historic kraals, graves and significant battle sites commemorate the bloody history of the region. The south coast, more densely populated by far, is characterized by contiguous holiday villages – with Margate at the centre of the so-called Hibiscus Coast. And inland from Port Shepstone, the Oribi Gorge Nature Reserve provides refuge for leopards and birds, and respite for nature-loving holiday-makers.

Despite its stature as a tourist mecca and the fastest-growing city in South Africa, Durban – which also boasts the busiest harbour in Africa – is not capital of the province. Elegant Pietermaritzburg, 100 kilometres inland, bears this title. Renowned for its red-brick Victorian architecture and lush gardens and parks, it has an air of grace and tranquillity. Among its many notable buildings are the old Natal Parliament and the City Hall – monuments to an era of exuberant ornamentation.

FAR LEFT  A benevolent climate with an average of 230 sunny days a year, glorious beaches on the warm Indian Ocean and sparkling beachfront pools make Durban one of the country's premier holiday destinations.

LEFT  Visitors can view performing dolphins and other aquatic creatures at close quarters at Seaworld, located along Durban beachfront's Golden Mile.

ABOVE  A Zulu rickshaw-operator sports flamboyant headgear and beadwork. Numbering nearly 1 000 in the 1930s, rickshaws have dwindled to about 15 today.

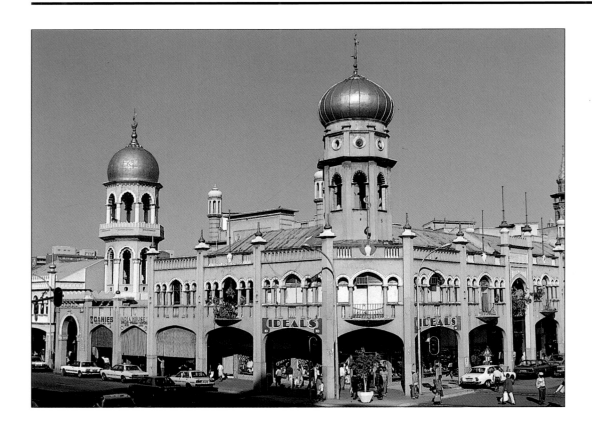

ABOVE  The large Asian population, established in Durban for almost 140 years, has a significant influence on the business, cultural and social affairs of the city. Both Hindu and Muslim communities are represented and their festivals and holy days are commemorated in intricate celebrations throughout the year. The Muslim community's fine mosque in Grey Street is reputed to be the biggest in the southern hemisphere.

BELOW LEFT AND RIGHT  The Indian Market is an Aladdin's cave of jewel-coloured fabrics, spices, sparkling brassware and fresh produce. It is possible to buy almost anything here – you simply have to ask. Friendly shopkeepers will show you how to wrap a sari the traditional way, and readily share their family recipes for spice mixes.
RIGHT  The graceful dome of the Muslim shrine is a landmark in Umgeni.

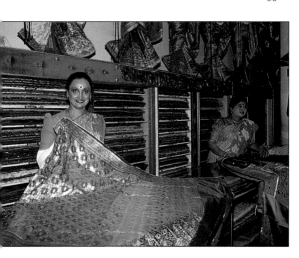

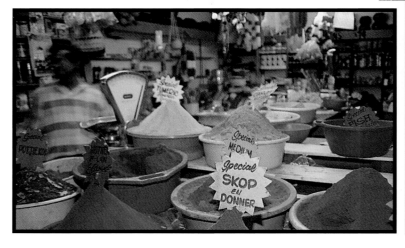

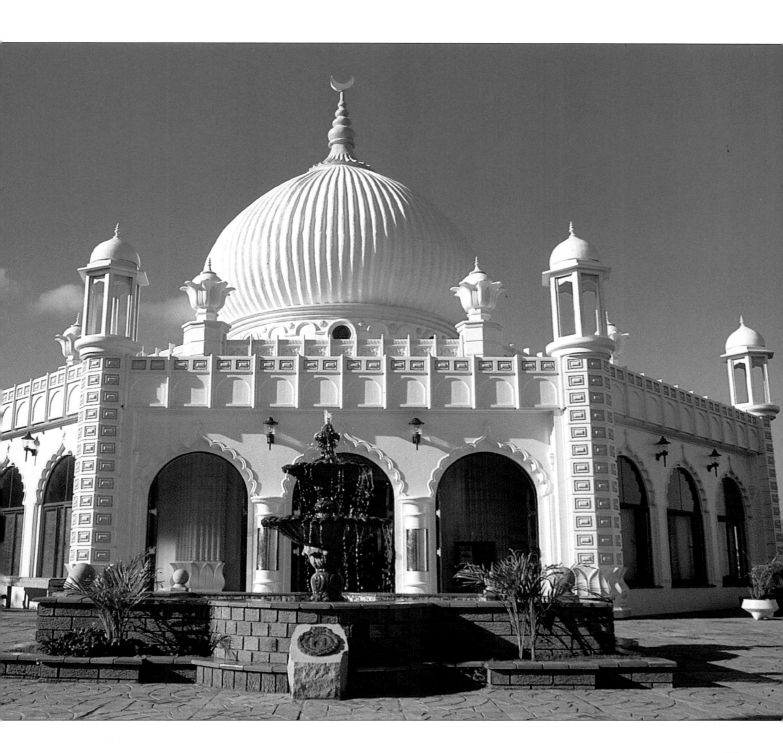

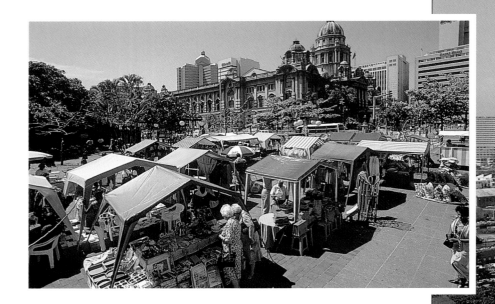

ABOVE  Almost every city in South Africa hosts a flea market, where bargain-hunters are able to track down cut-price clothing, bric-à-brac, ethnic art, books, plants and fresh produce. Durban's flea market is held near the Amphitheatre (Lower Marine Parade) every Sunday throughout summer.

RIGHT  Durban's imposing colonial-style City Hall is modelled on the city hall in Belfast, Northern Ireland. Straddling West and Smith streets, about 1,5 kilometres from the beachfront, it is the focal point of the historic Francis Farewell Square – named after one of the men who set up an ivory-trading base with the Zulus in 1824. Durban is one of the fastest-growing cities in the world, and its harbour, the Bay of Natal, one of Africa's largest cargo ports. Although synonymous with sea, sun and fun, Durban has a serious side and offers a wealth of other attractions: the botanical gardens, supporting 20 hectares of subtropical plants, a world-renowned orchid house, a natural history museum, a snake park and, on the Umgeni River, a bird sanctuary with cliffside aviaries.

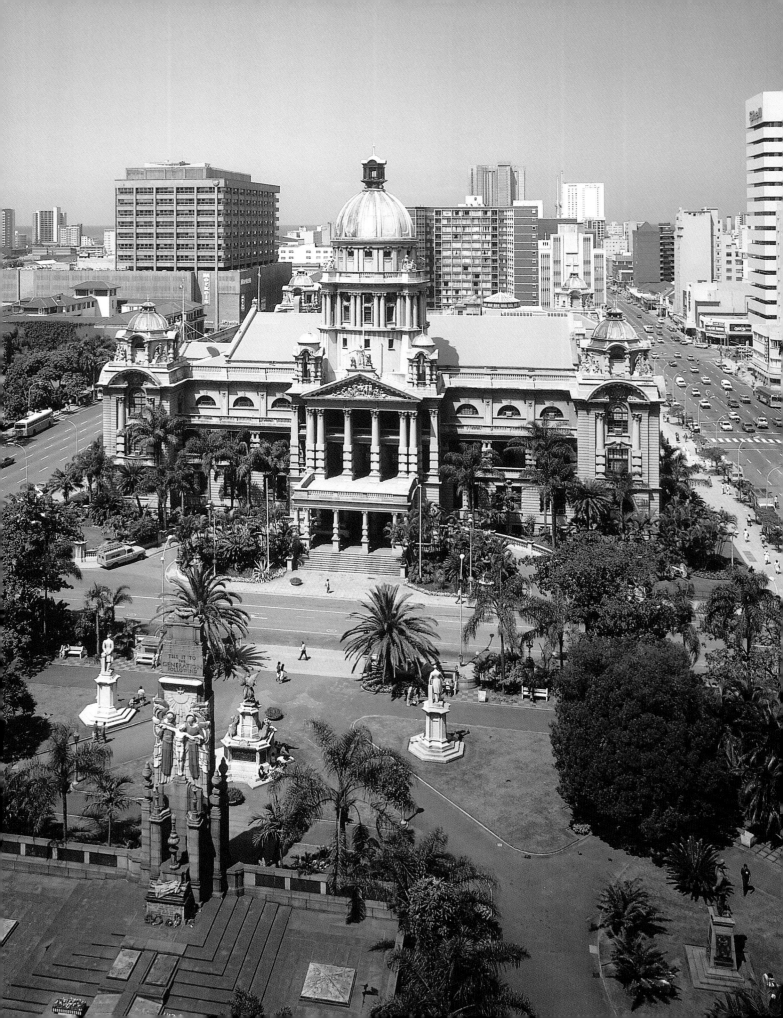

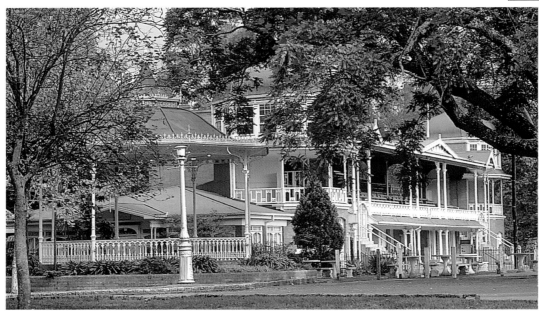

ABOVE AND RIGHT  Pietermaritzburg is studded with excellent examples of lavishly ornamented, red-brick architecture. The Pavilion (above) and City Hall (right) are among the most noteworthy. Home to the University of Natal, and capital of the province, the town is named after two Boer leaders (Piet Retief and Gert Maritz) but retains strong British influences. The delightful outlying areas – the Midlands – are dotted with quaint villages, wildlife reserves and several resorts centred around the region's waterfalls.

BELOW LEFT  North-west of Pietermaritzburg, the impressive Howick Falls plunge some 95 metres down a vertical cliff face into the Mgeni River. Other cascades nearby are the Shelter and the spectacular 105-metre-high Karkloof Falls.

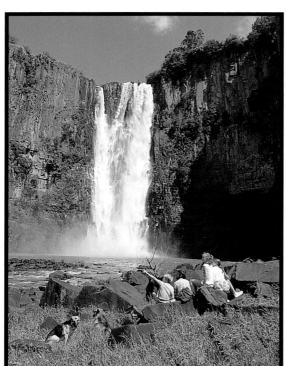

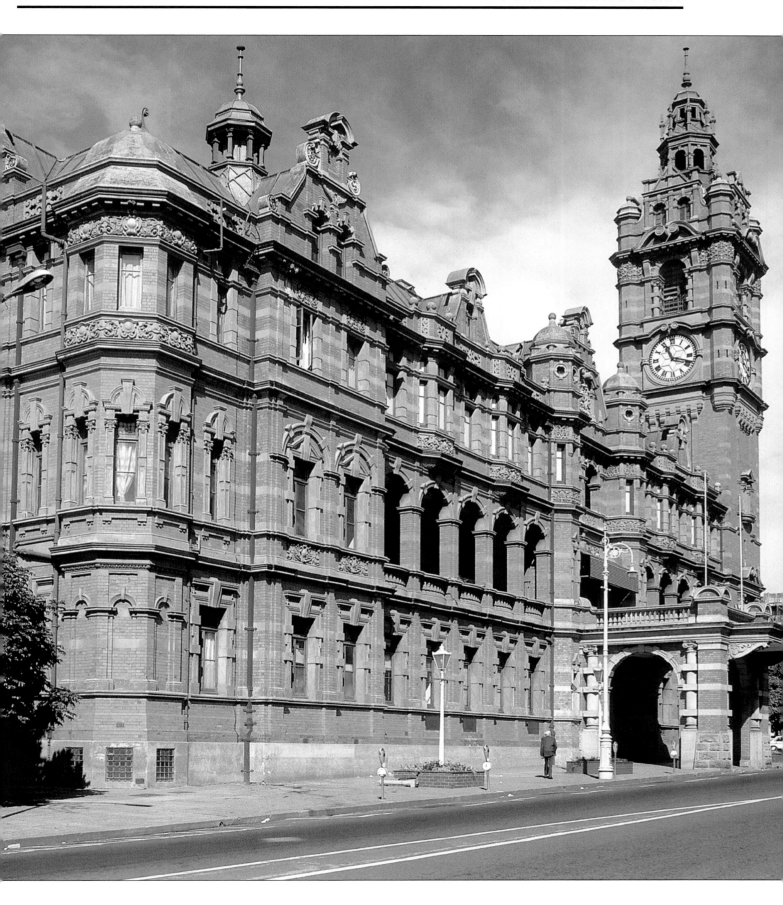

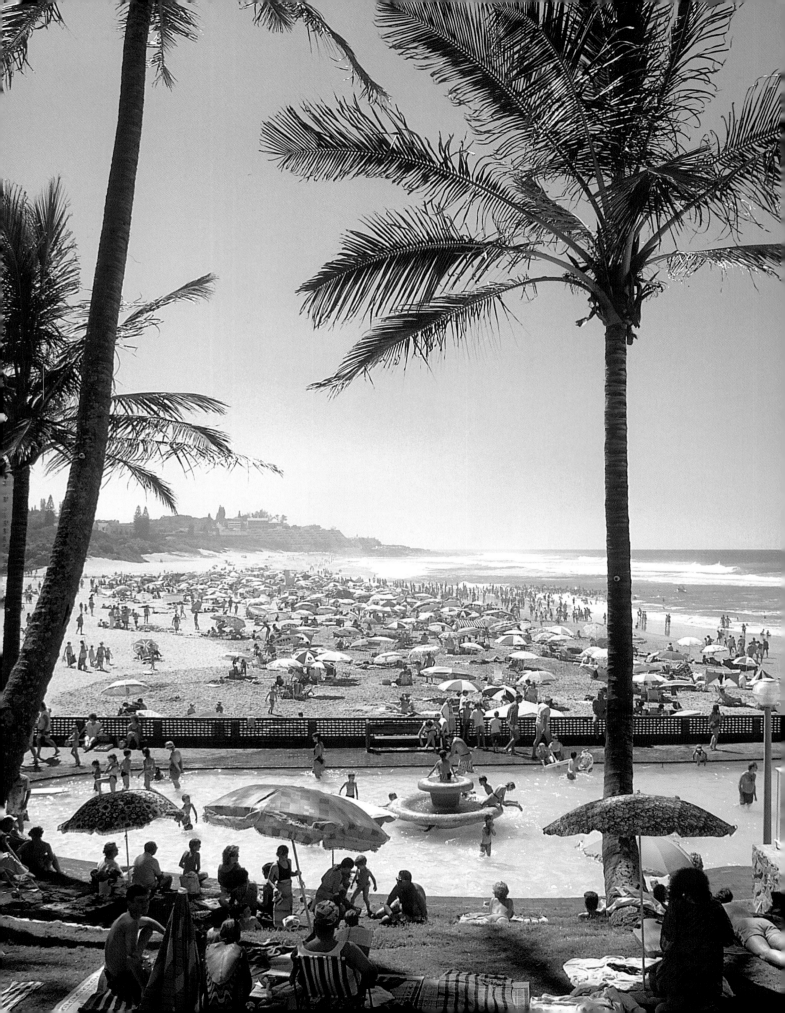

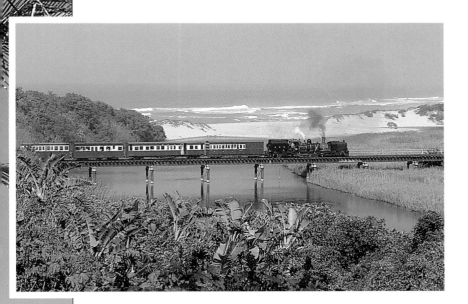

LEFT   The railway line hugs the KwaZulu-Natal south coast, providing passengers with an almost continuous vista of beaches, estuaries and sub-tropical vegetation.

BELOW   With sea temperatures often a temperate 25°C along the KwaZulu-Natal coast, watersports predominate as a leisure activity. Shark nets protect bathers at all the major resorts, and anti-shark patrol boats regularly service the nets – first introduced as a protective measure in 1952.

LEFT   KwaZulu-Natal's south coast resorts merge to form a string of pretty and vibrant seaside settlements. Margate, named after the popular English seaside resort, started as a coastal farm but today vies with Durban as a tourist playground. With its sheltered swimming beach, tranquil lagoon, paddling pool and Olympic-sized freshwater pool, it is perfect for parents with young children.

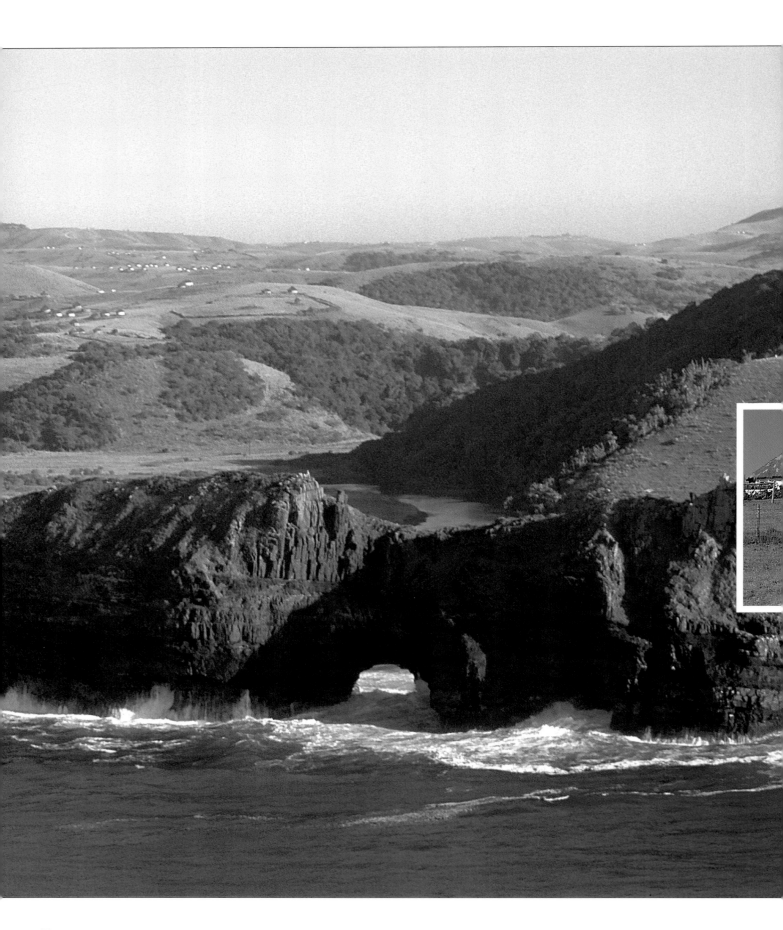

# LAND OF THE XHOSAS

*A wild and golden coast*

T HE EAST COAST EXTENDS southwards through 'the land beyond the Kei River' – fomerly Transkei – lingering on remote beaches and lapping round lagoons and estuaries. It continues on through the Border and former Ciskei regions to the river port of East London and, finally to the friendly city of Port Elizabeth. The Wild Coast, the Enchanted Coast, the Romantic Coast, the Sunshine Coast – each is aptly named and as captivating as the one before. The stretches of silvery beach, havens for shell-seekers, fishermen and seabirds, are interrupted only by tiny ocean- and riverside resorts and several casinos.

The Wild Coast earns its title as much from its untamed, rugged beauty as from the coastal waters that have claimed countless lives. For travellers with time there are coastal hiking trails providing a safer means of passage along these shores. Starting at the pretty riverside resort of Port St Johns – named after the *São Jão*, the first recorded ship wrecked in South African seas in 1552 – the Wild Coast Trail is one of several which meander around exquisite estuarine lagoons and through tracts of rich indigenous forest. No less charming than its coastline is the interior, where Settler cities, such as Grahamstown, mission settlements, old forts and military strongholds are redolent of the nine bloody frontier wars fought here in the last century. Known as the City of Saints (based on its 40 churches) and the City of Scholars (for its fine schools and university), Grahamstown has more recently earned a reputation as a city of the arts. Here, for a short spell each June, thousands of visitors hungry for the latest offerings in the performing arts converge on the city for the Standard Bank National Festival of the Arts, offering seven thrilling days of cultural indulgence.

The Eastern Cape boasts Africa's most southerly herd of elephant, in the Addo Elephant National Park. The rich, nourishing vegetation – chiefly the spekboom – sustains some 180 elephant. Buffalo, black rhino, kudu, eland and nearly 200 bird species can also be seen. Near Addo, 72 kilometres from Port Elizabeth, is Shamwari, the only Cape reserve with the 'Big Five' as an attraction.

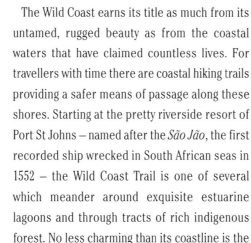

FAR LEFT The isolated sandstone massif, simply named Hole-in-the-Wall by the British, is regarded with reverence by the Xhosa people who have given it many evocative names. One is esiKhaleni (place of great noise), most apt at high tide when waves roar through the rocky arch.

LEFT Xhosa huts are brown on the west side and white on the east, a temperature-regulating measure which enables the clay walls to deflect heat during the day, and retain warmth for the cold nights.

ABOVE A young Xhosa man, his body painted with white ochre, prepares for his ritual entry to manhood.

RIGHT  Traditional Xhosa huts and kraals face the morning sun on the coastal hills near Coffee Bay in the Eastern Cape. Hikers can follow a meandering path over the hills from Coffee Bay to Hole-in-the-Wall, which is a distance of approximately 20 kilometres.

BELOW  For those who do not want to walk, a dirt road leads to Hole-in-the-Wall from Coffee Bay. The view just over the hill is breathtakingly beautiful.

OPPOSITE TOP  Open for business. A roadside vendor offers cabbages, pumpkins, potatoes and milk for sale to passers-by.

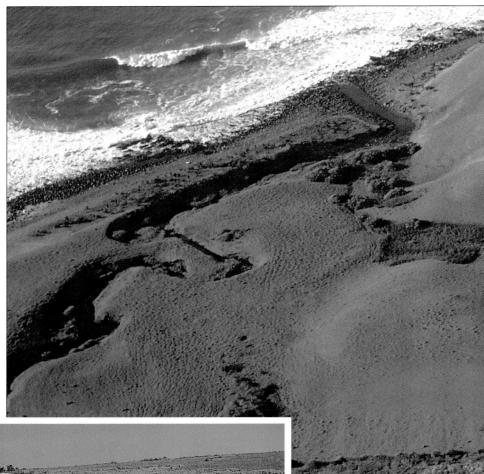

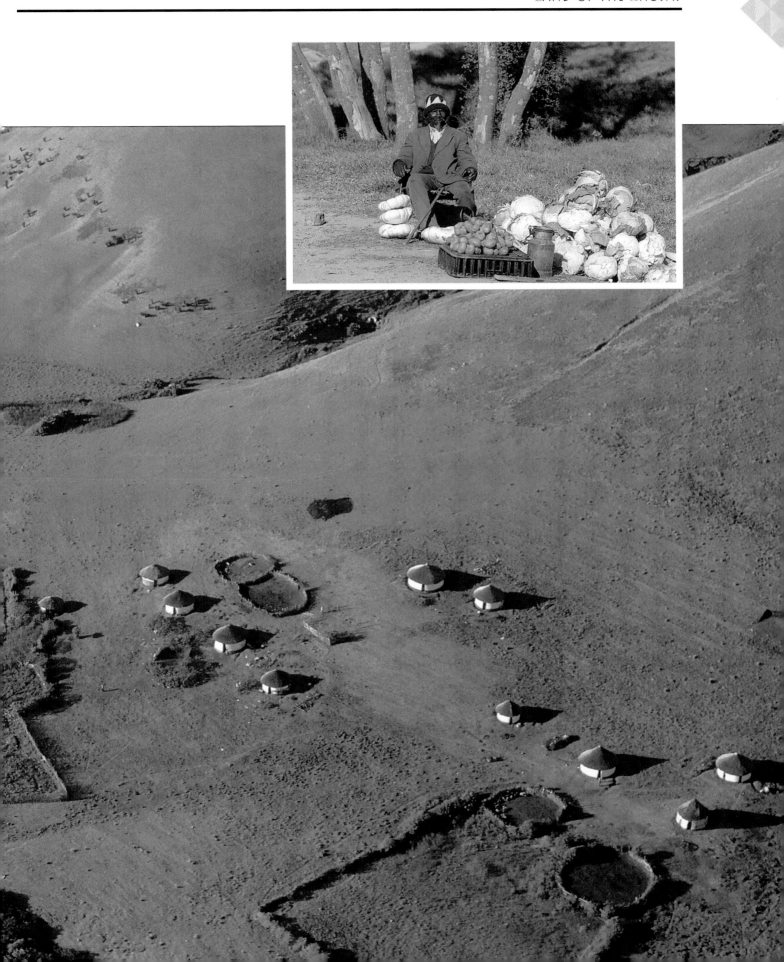

ABOVE A replica of the original cross planted by Bartolomeu Dias in 1488 stands in front of the Port Elizabeth City Hall.

LEFT The City Hall's clock tower. Built in 1858, the building was badly damaged by fire in the 1970s and rebuilt with a modern interior.

BELOW Donkin Terrace houses, privately owned national monuments, step smartly down towards the sea. The houses are examples of early Victorian architecture.

RIGHT Port Elizabeth's old public library opened in 1902. The terracotta façade was made in England and shipped to South Africa in numbered sections for assembly on site.

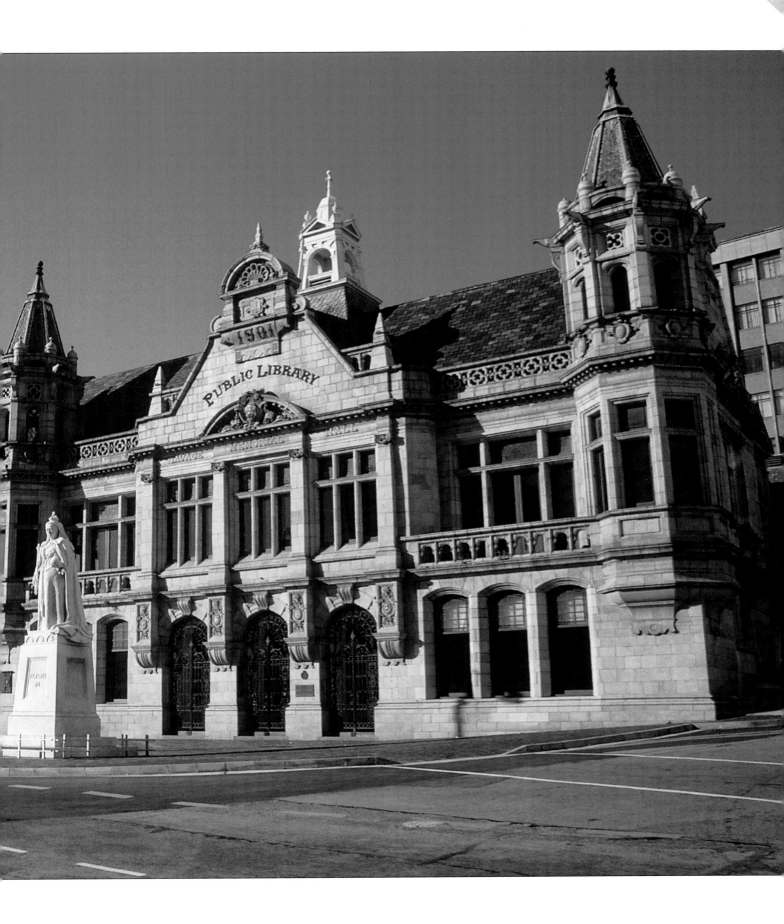

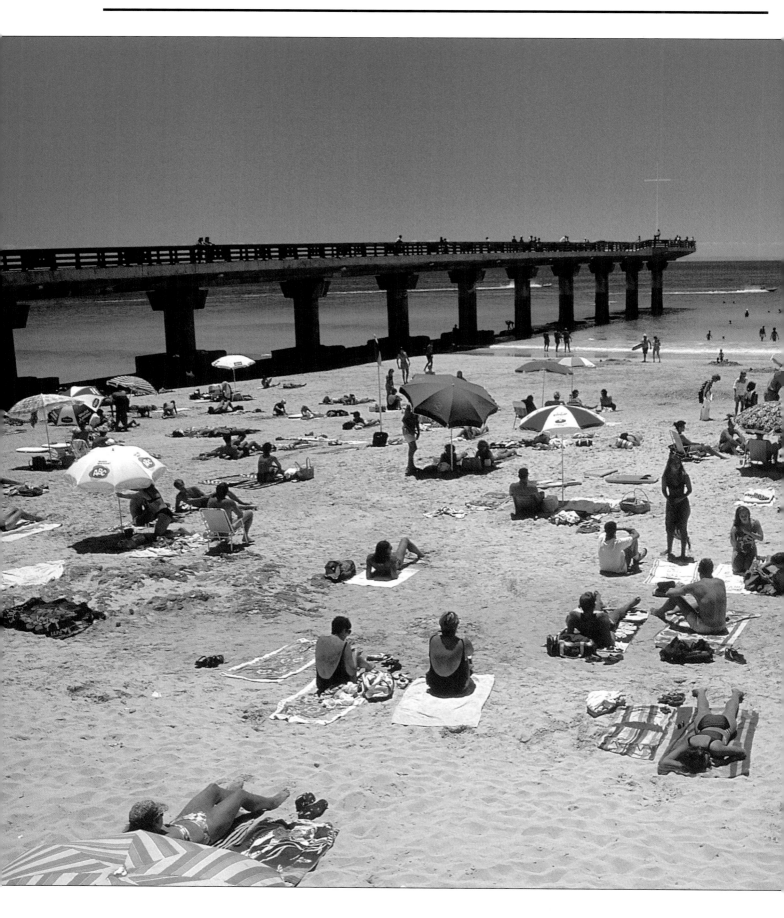

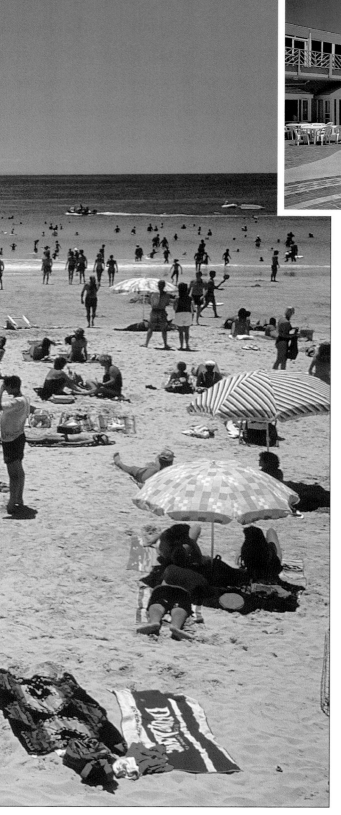

LEFT  Deservedly acclaimed as capital of the Sunshine Coast, Port Elizabeth's safe beaches make the city a perfect summer holiday destination.

ABOVE  The newly developed Humewood beachfront has outdoor cafés and sunny piazzas.

BELOW  The performing dolphins at Port Elizabeth's Humewood marine complex (oceanarium, snake park, tropical house and museum) are world renowned for their brilliant tricks. Several have been bred in captivity.

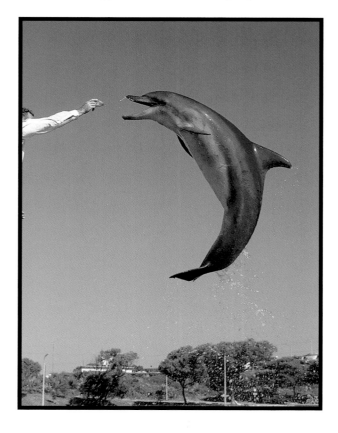

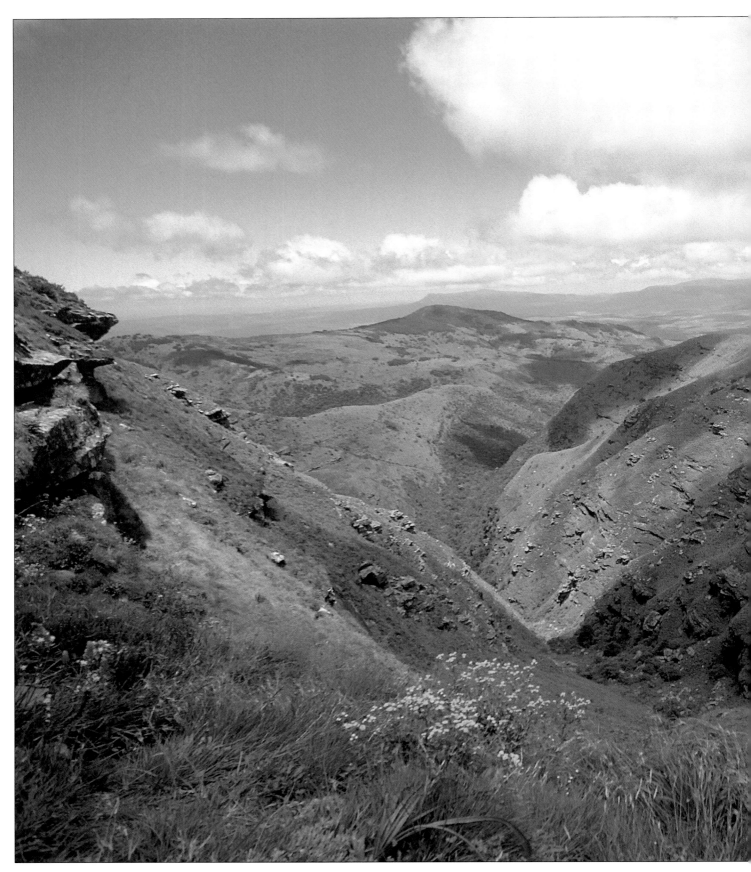

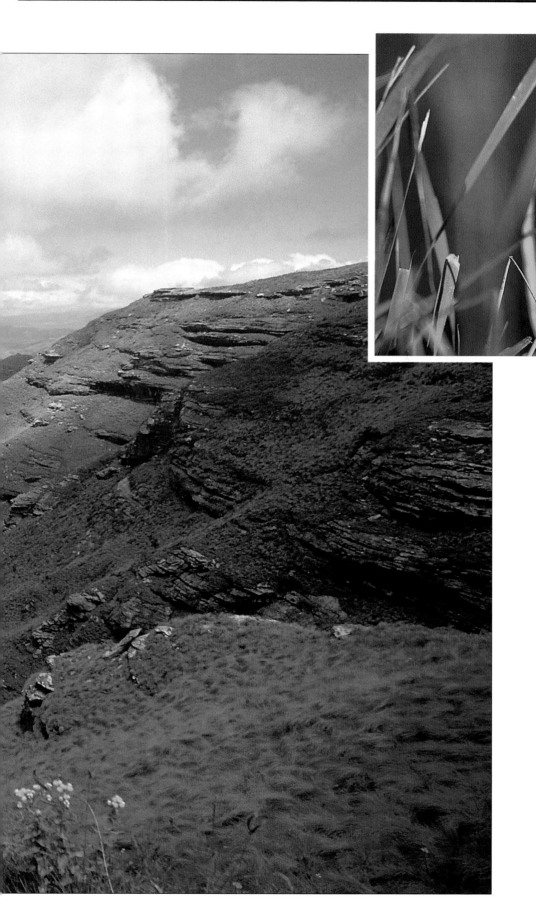

LEFT The Katberg Pass traverses grassland and forests in a gloriously scenic drive bridging the Great Winterberg and Amatole ranges. Stopping places along the route provide windows on rolling Eastern Cape vistas, and access points for a myriad lovely picnic sites, hikes and drives. The pass, 1 700 metres high at the summit, was designed and partly built by the brilliant road engineer Andrew Geddes Bain, who commenced the work in 1860.

ABOVE Widely distributed in all but the most arid parts of South Africa, the red bishop *(Euplectes orix)* is a small, gregarious bird, found in flocks of up to several hundred. They feed on seeds and grains, sometimes causing quite substantial losses to grain crops. The males engage in a distinctive display which involves fast-beating wings, puffed plumage and bee-like cruising flight.

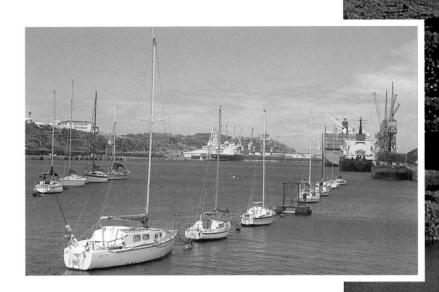

ABOVE RIGHT East London's harbour at the mouth of the Buffalo River is a safe haven for yachts.
BELOW Elephants living in the Addo Elephant National Park have ample water and forage. The lush Sundays River Valley, with its dense cover of spekboom, supports elephants and a variety of other game, as well as the curious, flightless dung beetle.
RIGHT Nature shows her forms and colours to brilliant advantage along the Eastern Cape coast.

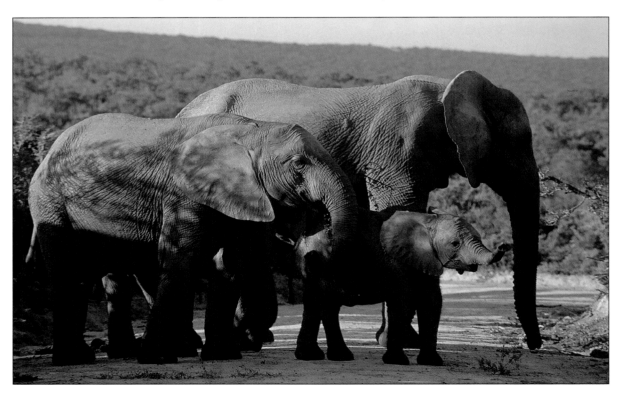

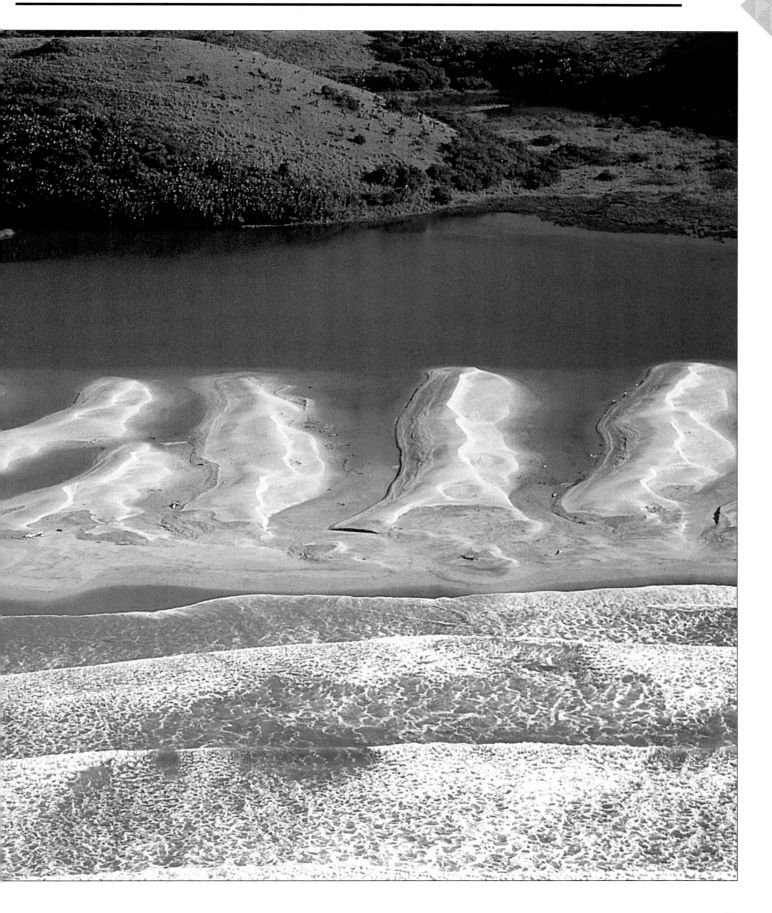

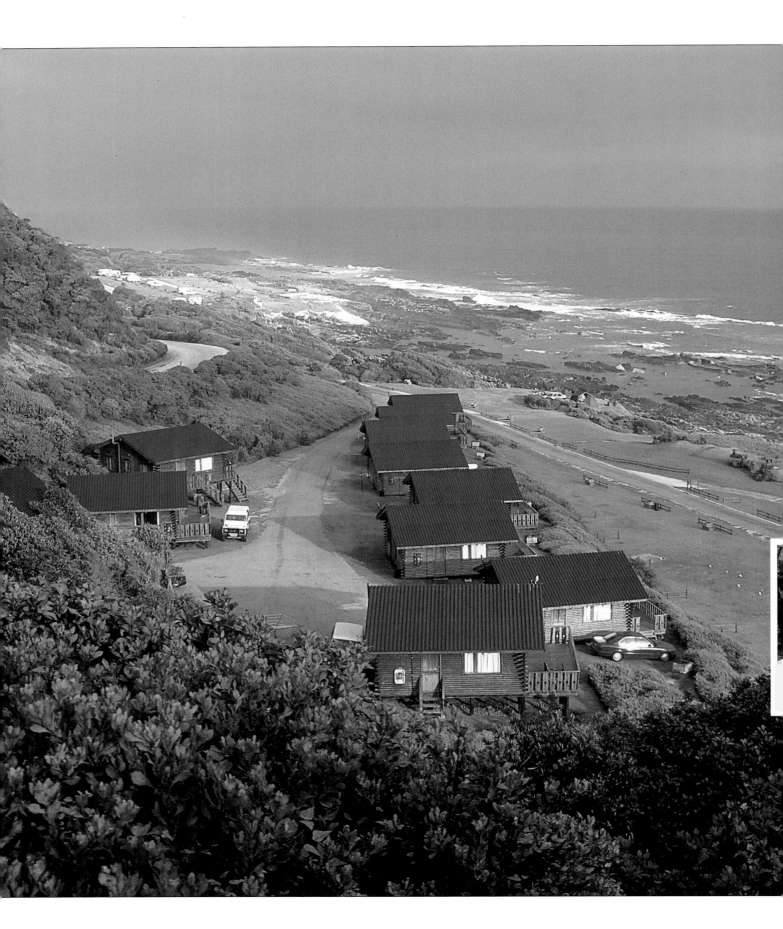

# THE GARDEN ROUTE

*Evergreen enchantment*

OLLOWING THE CURVE OF the coast for 300 kilometres from Storms River to Mossel Bay, the Garden Route cuts a swathe through rocky oceanside cliffs, beaches, estuaries, lagoons and valuable indigenous forests set against the slopes of the Tsitsikamma and Outeniqua mountains. Here and there it probes inland through passes and gorges to give a glimpse of the contrasting interior. Much of the route is lined with sanctuaries to protect the specialized flora and fauna of the moisture-laden coast. The towns and resorts hugging the beaches and river mouths – 'Plett', Knysna, Wilderness, Great and Little Brak, and Mossel Bay – seethe with sun-seekers in the high season. Some, like Mossel Bay, Knysna and Plettenberg Bay, were important ports or whaling stations in times gone by.

The Garden Route is best explored by road or on foot. The Otter Trail covers 48 kilometres of exquisite coastal scenery over five days, starting from Storms River Mouth and finishing at the Groot River Mouth at Nature's Valley. Visitors book months, even years, in advance to secure a place on this trail.

Plettenberg Bay (the 'Bay of Content') is the most luxurious of Garden Route destinations. Its beaches – with clean, warm water, safe swimming and fine white sands – are incomparable and in February, when the Johannesburg jet set returns home, delightfully deserted.

Knysna, with its idyllic lagoon and prolific lodges and restaurants, is at the centre of a national lake area of major significance. The lagoon is guarded at the sea by two massive cliffs – the Heads. The lagoon is a vast natural hatchery for oysters, which can be sampled along with the excellent local ale in open-air taverns on its banks. Knysna, appropriately called the 'pearl' of the Garden Route, boasts some of the most expensive coastal real estate in the country.

Mossel Bay was the first South African landfall for Bartolomeu Dias; giving the Cape of Storms a wide berth, he sailed on and landed at Mossel Bay. Aside from its architectural and commercial importance (in the boom days of the early twentieth century it was the main port through which ostrich feathers were exported), it has one of the world's most amenable climates: on average, four cloudy days a month.

FAR LEFT  The Storms River Rest Camp, situated near the river mouth in the heart of the Tsitsikamma National Park, is perfectly sited for five beautiful walking trails through the area. Visitors have a choice of comfortable bungalow accommodation, caravanning or camping. Whatever option, the site commands arresting views of one of the most pristine coastlines in South Africa.

ABOVE LEFT  An awesome spectacle: the massive girth of an 800-year-old Outeniqua yellowwood *(Podocarpus falcatus)*, the 'Big Tree', dwarfs visitors in the cool depths of the Knysna forest.

ABOVE  A suspension bridge spanning the Salt River links tall, densely vegetated sea cliffs, a few kilometres west of the end of the Otter Trail in Nature's Valley.

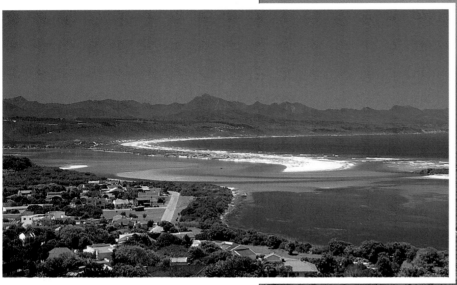

ABOVE  Lookout Beach, Plettenberg Bay, set against the backdrop of the Tsitsikamma Mountains, is reputedly the best beach in South Africa.

RIGHT  Oceanside condominiums, luxury homes and a glamorous timeshare resort cater for an annual influx of visitors who revel in the perfect weather and safe, warm water bathing of Plettenberg Bay's famous beaches.

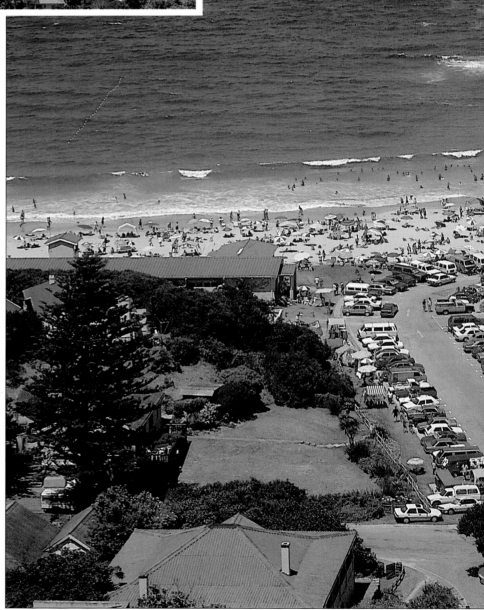

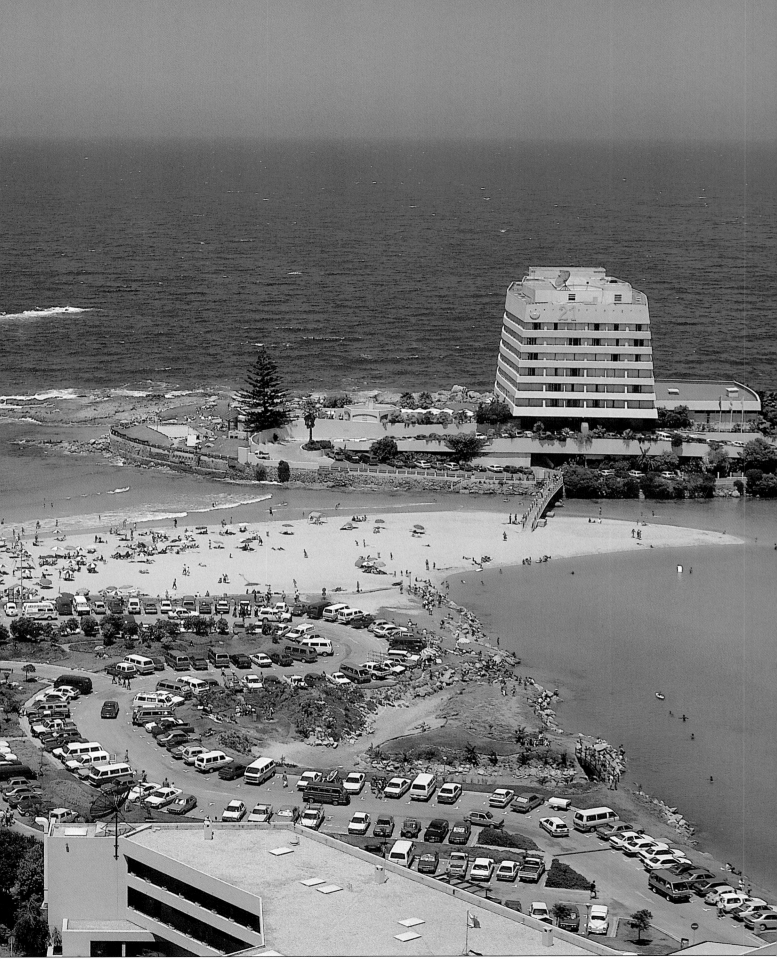

ABOVE  The Garden Route offers a wealth of walking trails, many of which take visitors past deep, fresh-water pools under a dense forest canopy. The cola-tinted water, coloured by tannins on the forest floor, is chilled and clean.

ABOVE RIGHT The flamboyant, fruit-eating *Tauraco corythaix*, or Knysna lourie, has a raucous shriek which can be startling in the depths of the forest.

OPPOSITE The Garden Route boasts the greatest stretch of contiguous forest anywhere in South Africa; an evergreen world, stringently protected, that extends for almost 200 kilometres.

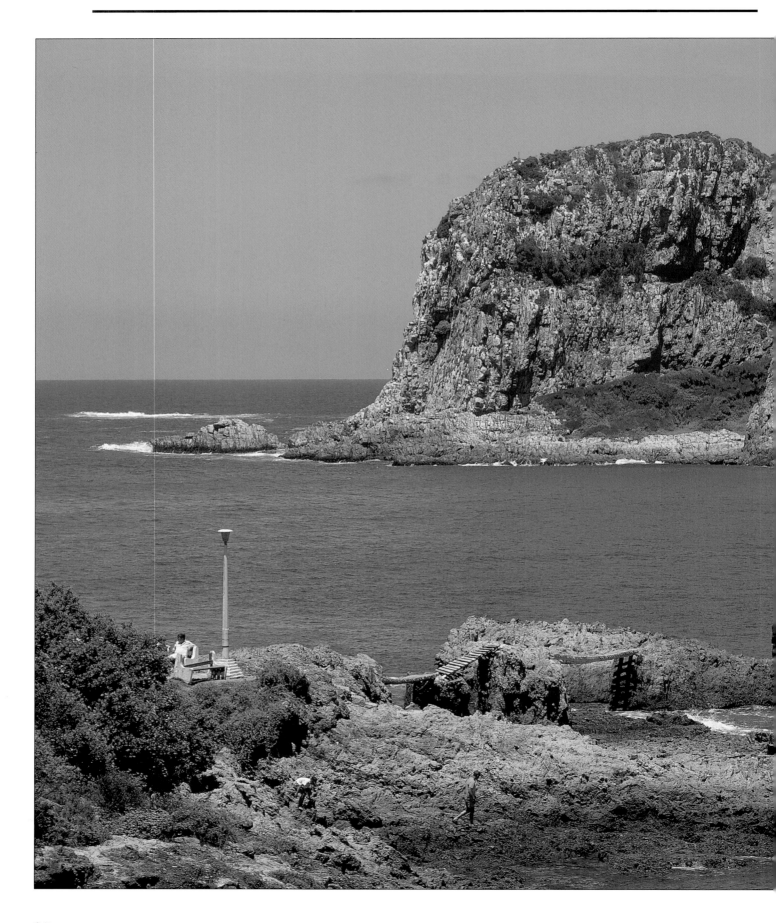

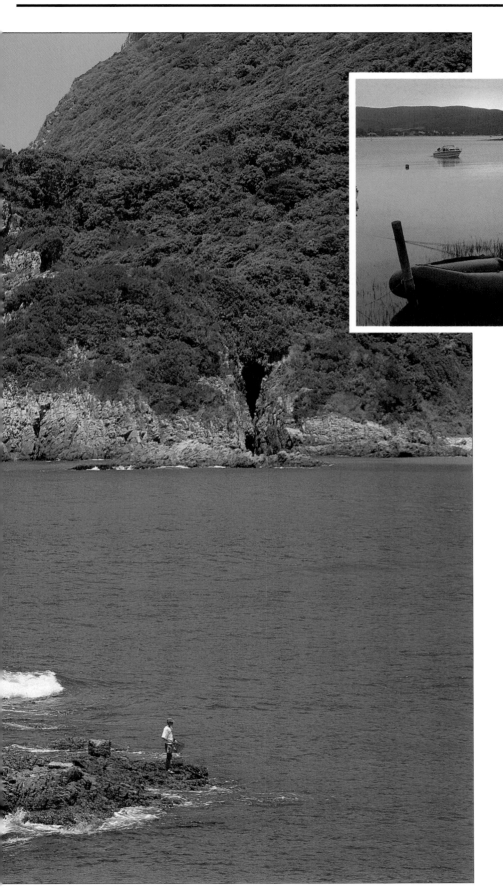

LEFT A majestic pair of sandstone cliffs, the famous Knysna Heads, guard the entrance to the placid Knysna Lagoon.

ABOVE Life in Knysna revolves around the languid lagoon, one of the largest river mouths in the country. In all its varied moods, the lagoon is an important ecosystem, providing rich nutrients for shelled organisms, which in turn attract prolific numbers of birds and fish. It is also the hatchery for a large oyster farming enterprise.

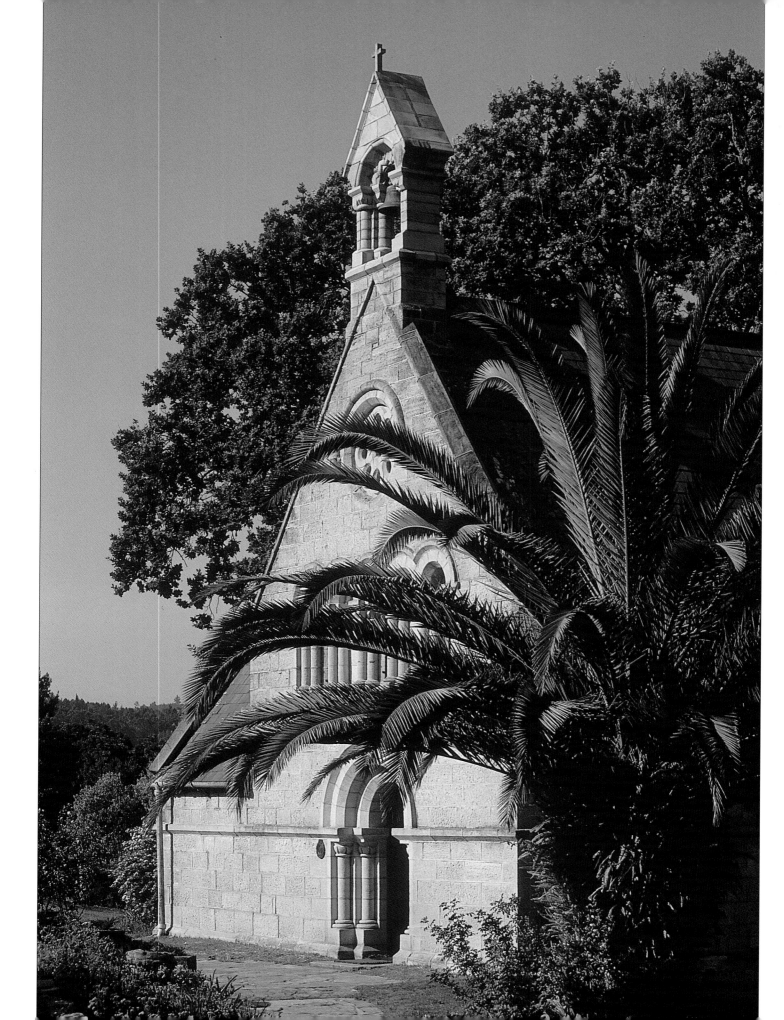

OPPOSITE The Norman-style Holy Trinity Church at Belvidere near Knysna is a tiny architectural delight, built in 1855 as a place of worship by the Duthie family.

TOP Millwood House is all that remains of a small mining town that sprang up during Knysna's short-lived 'gold rush' of 1866. Work is now under way to revive the mining relics and open a mine museum at the site.

ABOVE A rich display of objects crafted from indigenous wood of the Knysna forest livens up a Knysna curio shop.

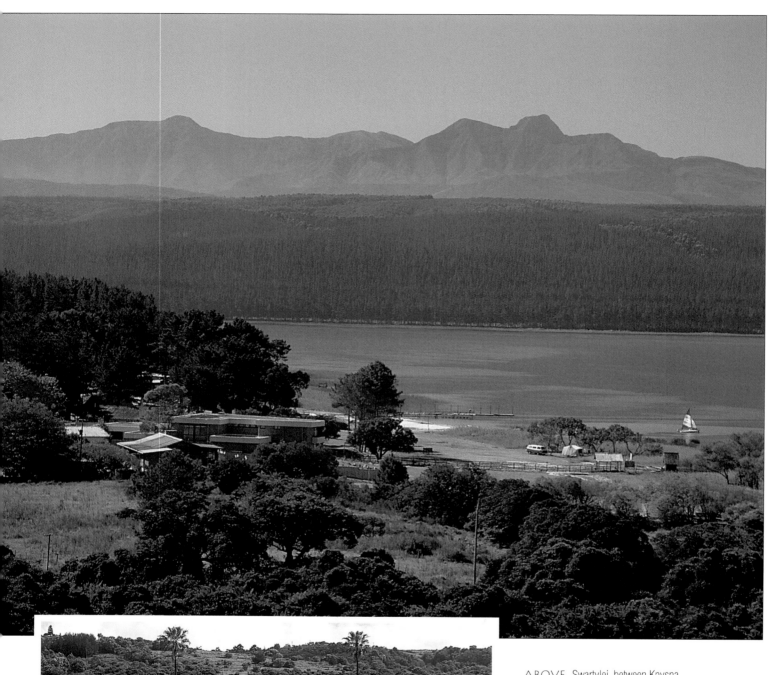

ABOVE Swartvlei, between Knysna and Wilderness, is a popular destination for sailors, hikers, bird-watchers and nature-lovers.

LEFT Idyllic lagoonside holidays are generously provided for with numerous resorts (such as Fairy Knowe shown here), caravan parks and camping sites throughout the lake region of the scenic Garden Route.

RIGHT  Sport and leisure are not limited to the many stretches of water at Wilderness. Here, a para-glider catches the gentle thermals above the lakes.

BELOW  Wilderness beach from Dolphin's Point, one of the most spectacular of the Garden Route views. Wilderness is at the heart of a coastline studded with fresh-water lakes and estuaries.

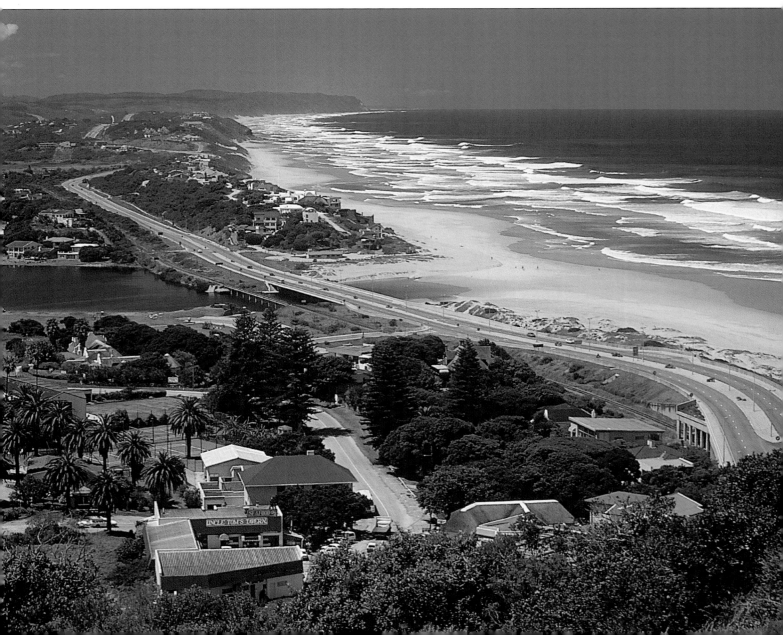

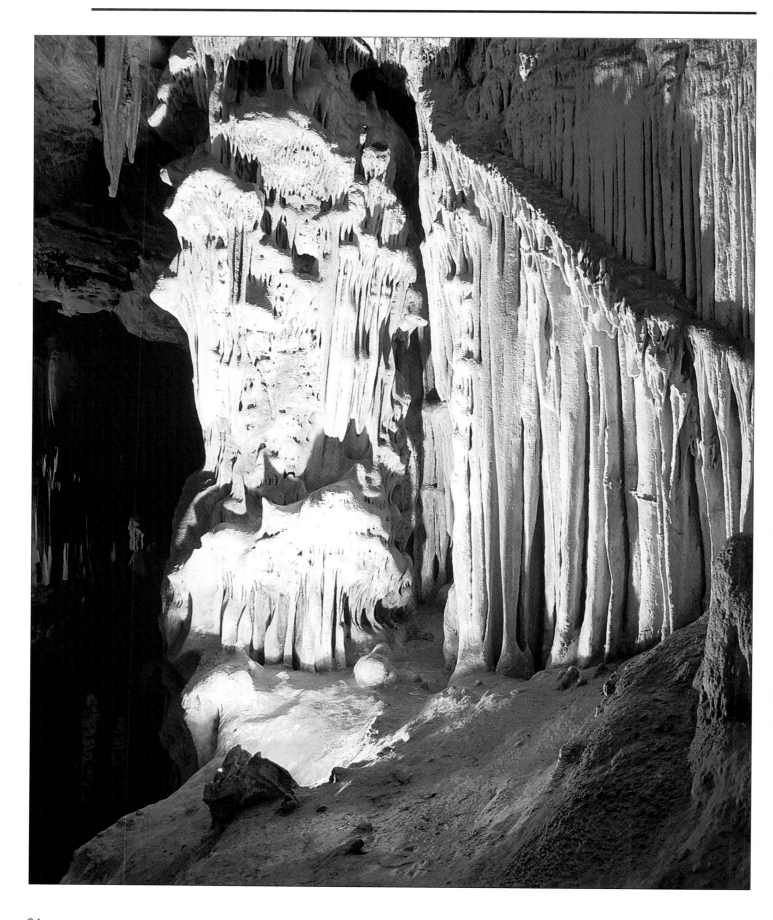

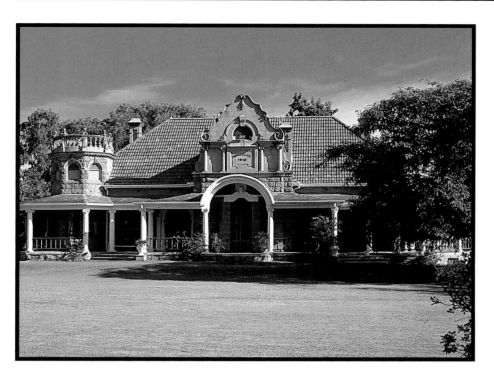

OPPOSITE  The magnificent Cango Caves, 20 kilometres outside Oudtshoorn, are considered among the finest dripstone caves in the world. Conducted tours take visitors out of the real world and into a fantasy wonderland of stalactites and stalagmites in a dazzling array of colours and strangely sculpted forms.

TOP LEFT  Many turn-of-the-century ostrich barons built lavish 'feather palaces' of golden sandstone with their fast-earned fortunes. Some of these still remain in Oudtshoorn and are preserved as national monuments, reminders of boom times for the small town.

BOTTOM LEFT  Content in a field of fresh lucerne, ostrich hens guard their young by day. At night the more dramatically plumed black male takes over for reasons of camouflage. Ostrich chicks are vulnerable to a host of diseases in their first year of life.

BELOW  A visitor to one of Oudtshoorn's commercial ostrich farms learns the basics of jockeying on the largest and most remarkable bird in the world.

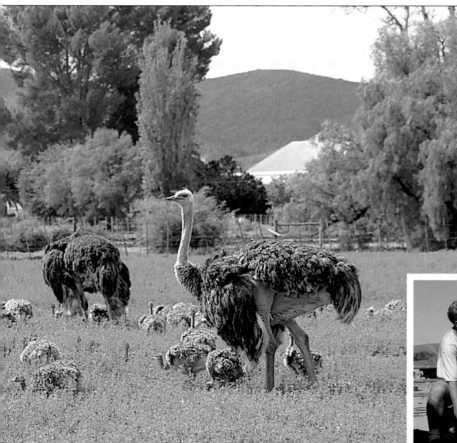

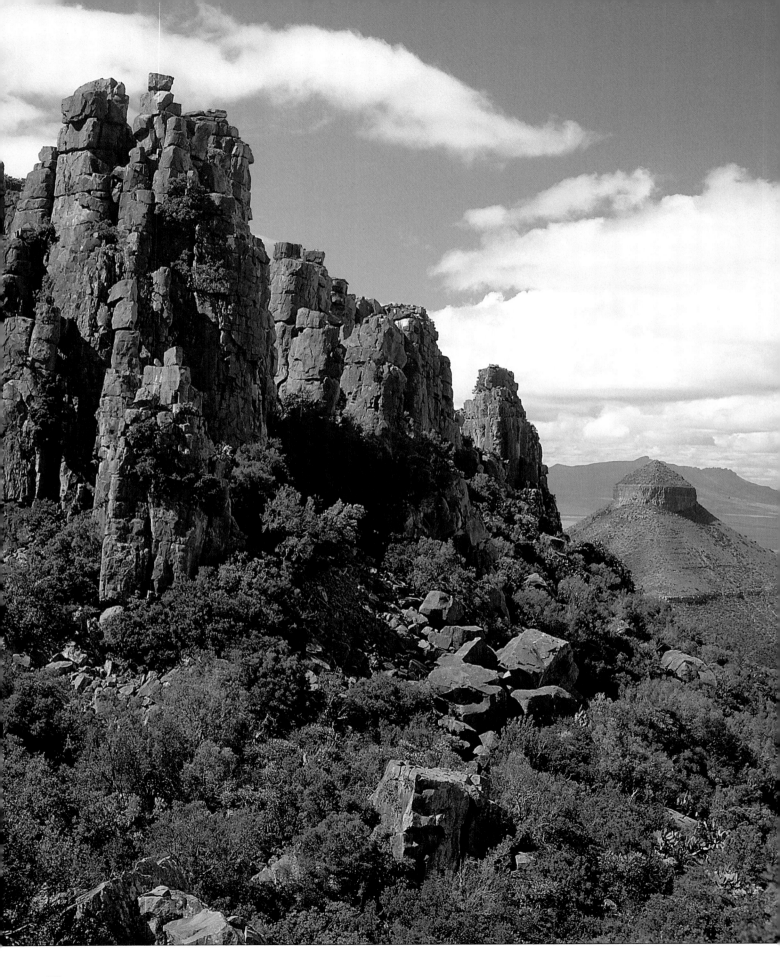

# THE SUNLIT INTERIOR

*A wilderness of many moods*

**A**FTER THE SOFT, MOIST beauty of the coast, the crisp air and uncompromising landscapes of South Africa's high, dry interiors are exhilarating. Separated from the coastal terrace by mountain ranges sweeping in a great horseshoe from the north-eastern Transvaal to the Western Cape, the interior is mainly semi-arid or arid in nature. Plant life is low and scrubby, adapted to overdoses of sunshine and not enough rain. Yet the land supports millions of sheep, ostriches and goats, yielding rich harvests of succulent mutton, wool and feathers for the farmers.

One third of the whole of South Africa is composed of the Karoo – the Bushmen's 'dry and dusty plain'. The Little Karoo, with the ostrich capital Oudtshoorn at its centre, runs along a narrow valley between the Outeniqua and Swartberg mountains. The Great Karoo lies to the north of the Swartberg, a vast region of far-flung towns and sunlit spaces, laying claim to the world's largest unbroken fossil record and a treasure trove of minerals. Beaufort West, birthplace of heart surgeon Chris Barnard, is its principal town, and the nearby Karoo National Park is a scenic and convenient stopover on the long highway between Cape Town and Johannesburg. Graaff-Reinet, 200 kilometres east of Beaufort West, is a meticulously preserved museum town with more national monuments than any other urban centre in the country. And in Kimberley, in the Northern Cape, the world's biggest man-made hole stands as a reminder of the most frenzied diamond rush in history, precipitated by the discovery of a tiny, shiny pebble in 1866.

In the far north, where the borders of the Cape, Namibia and Botswana are smudged in a haze of heat and sand, animals and plants undergo extraordinary adaptations to survive the harsh environment. The Kalahari Gemsbok Park and the Richtersveld are sanctuaries where some of the world's most unusual flora and fauna are found. The Richtersveld and the Augrabies Falls National Park to the east are bisected by the mighty Orange River. The arid northern bank gives over to the red dunes of the Kalahari, punctuated by vast salt pans and dry riverbeds. The southern bank is a greensward in the desert. Irrigation is by way of the river's ample waters, allowing cultivation of grapes, dates, cotton and palm plantations. The Augrabies Park covers an arid tract supporting drought-resistant flora, game and birds. Spectacular falls and rapids follow an 18-kilometre ravine with striking rock formations.

LEFT  Millions of years of erosion have sculpted the awesome Valley of Desolation, one of South Africa's scenic wonders, near Graaff-Reinet in the Great Karoo. The enormous breadth, stillness and expansive vistas from several vantage points in the valley embody all that is the Karoo.

ABOVE  Only the hardiest of plants, many of them extraordinary in form, survive the extreme heat and drought of the north-western Cape. The *basterkokerboom* or bastard quiver tree *(Aloe pillansii)* is one such plant, confined to a small, very hot and dry part of the Richtersveld.

ABOVE  A small trading store –
closed, in Karoo tradition, for lunch.
RIGHT  Graaff-Reinet is history itself,
with more than 200 national monument
buildings lining its elegant streets.
Tucked into a curve of the Sundays River
in a cleft of the Sneeuberg Range, the
town bears the title 'Gem of the Karoo'.
The Drostdy Hotel, extreme left, is a
working monument which was built in
1806 as the residence of the landdrost
or magistrate. The historic Dutch
Reformed Church – Groot Kerk – is the
focal point of Church Street. Built in
1887, it was modelled (like many other
major South African buildings) on an
English counterpart – in this case,
Salisbury Cathedral.

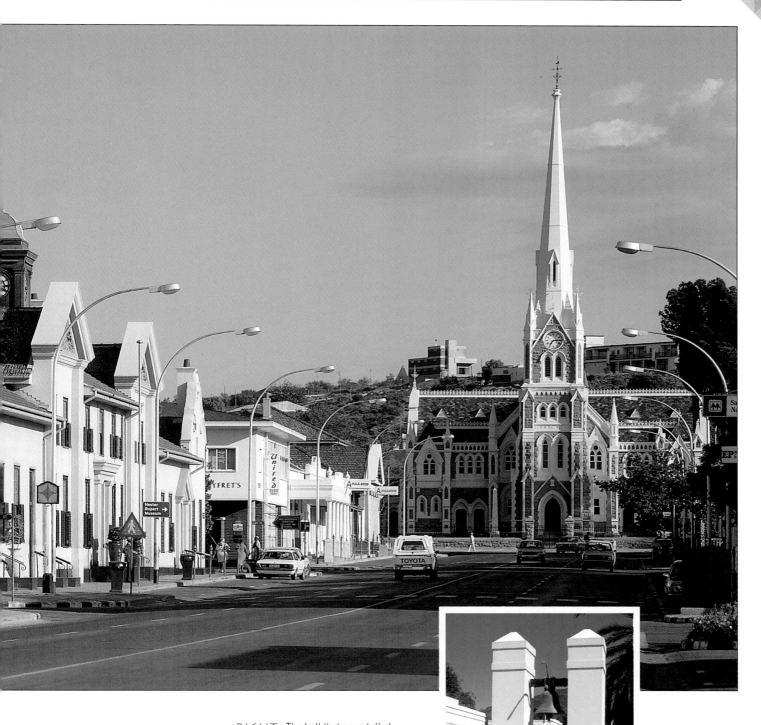

RIGHT  The bell that once tolled for toiling slaves outside their quarters in Stretch Court is now restored and part of the Drostdy Hotel complex.

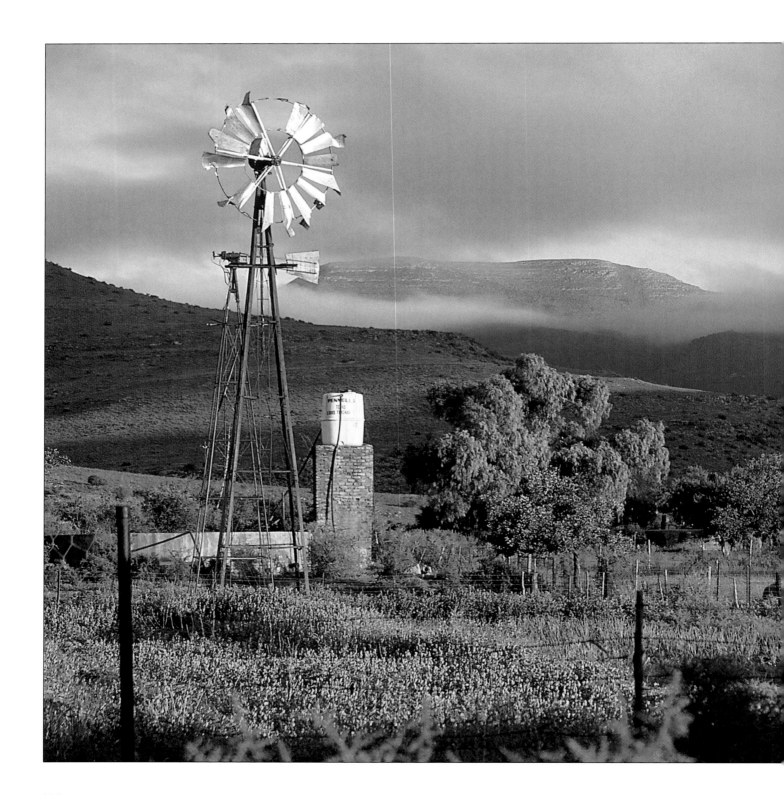

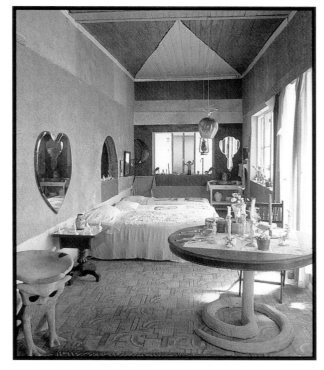

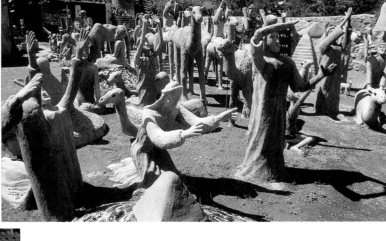

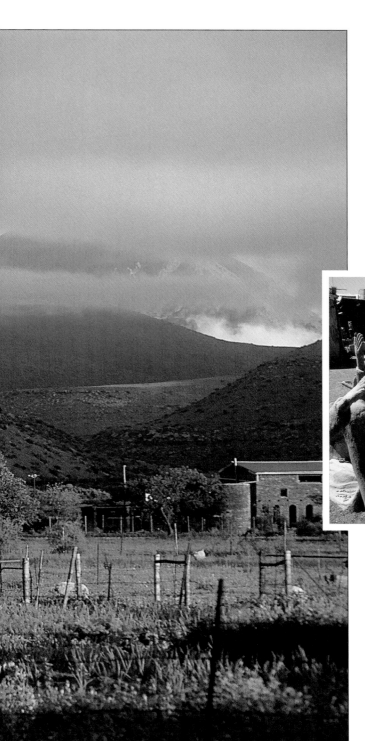

LEFT  The farming hamlet of Nieu-Bethesda, 50 kilometres north of Graaff-Reinet, is home to the South African playwright Athol Fugard. It is also known for the bizarre Owl House, now a museum but once home to the late Helen Martins, who spent many years here creating mysterious cement figures.

TOP  A bedroom in the Owl House is strikingly decorated with brightly painted walls and ceiling and adorned with Martins' sculpted furniture.

ABOVE  The house and grounds of the Owl House are filled with sculpted human and animal forms.

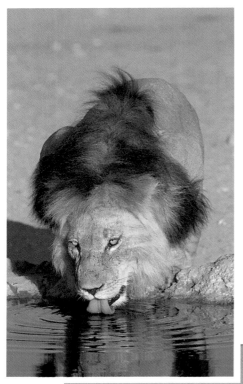

LEFT  The 'lap of luxury': a lion *(Panthera leo)* slakes its thirst at a Kalahari water hole.
BELOW  The remote wilderness of the Richtersveld National Park lies in a series of broad curves along the southern bank of the Orange River in the northernmost corner of the Northern Cape. On the far side of the river lies Namibia.

OPPOSITE TOP  The stately gemsbok *(Oryx gazella)* are superbly adapted to the intensely hot and dry conditions of the Kalahari. They are not dependent on a regular supply of surface water, and are equipped with a special cooling system: a fine network of veins in the nose ensures that the blood carried to the brain is first cooled by the animal's breathing.

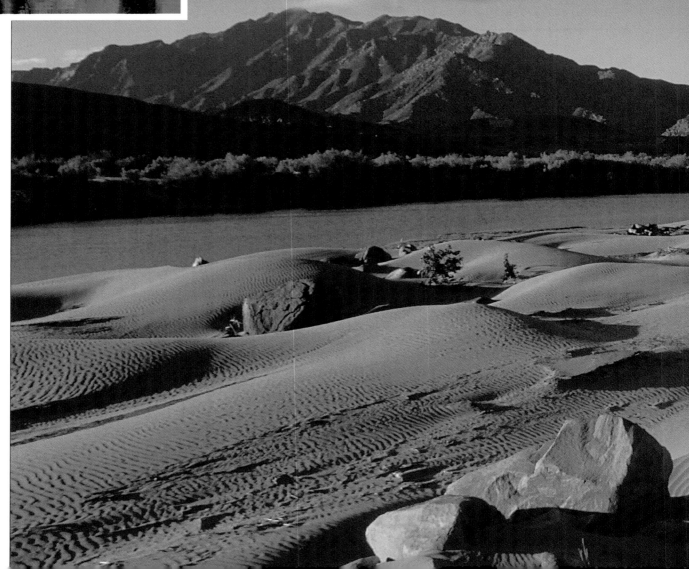

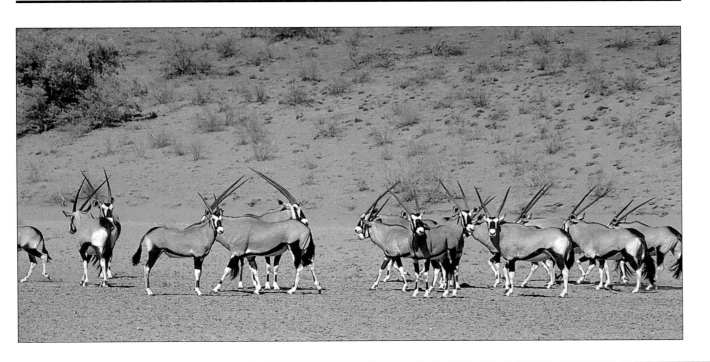

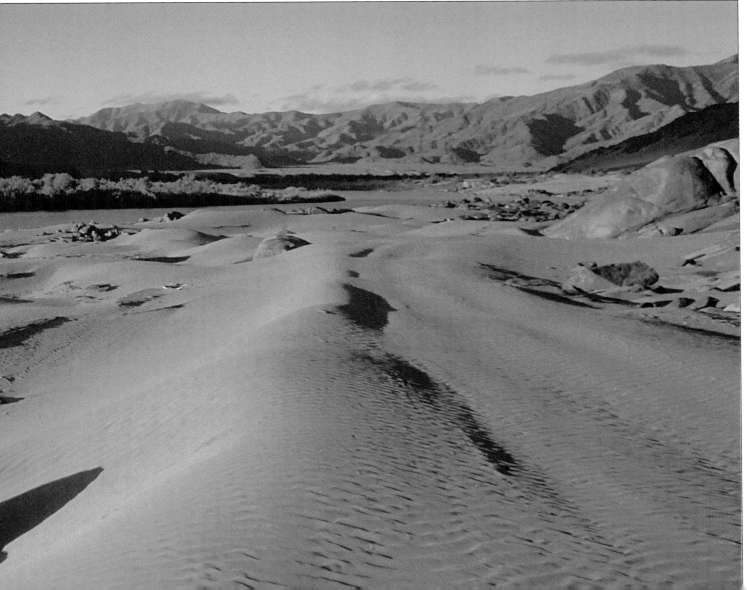

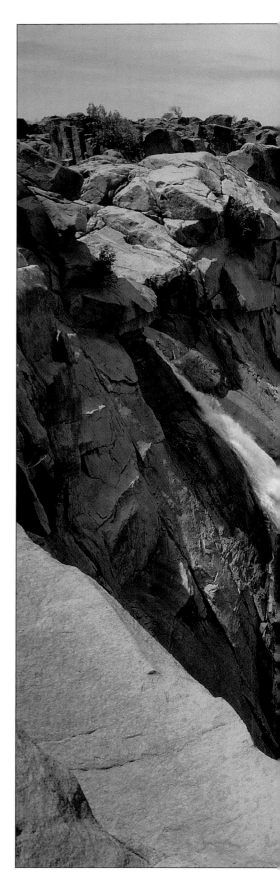

BELOW Modern-day adventurers can explore the lazier reaches of the Orange River by canoe. A popular trip starts at the oasis-like mission settlement of Pella, where date palms, figs, grapes and pomegranates are watered by a lifegiving spring which erupts into the dry, sun-baked plains. Other trips start further west at Vioolsdrif and terminate in the Richtersveld.

RIGHT *Aukoerebis* (place of the great noise), so called by the Khoikhoi. By whatever name, the mighty Augrabies Falls is one of the most awesome natural spectacles in Africa. It is set within 9 000 hectares of river landscape proclaimed as a park in 1967. At full flood, 19 waterfalls thunder more than 90 metres into the top end of the nine-kilometre-long granite gorge. At such times a massive column of spray and mist all but obscures the scene.

OPPOSITE TOP Among the creatures great and small that thrive in the austere conditions of this land is the southern rock agama *(Agama atra)*.

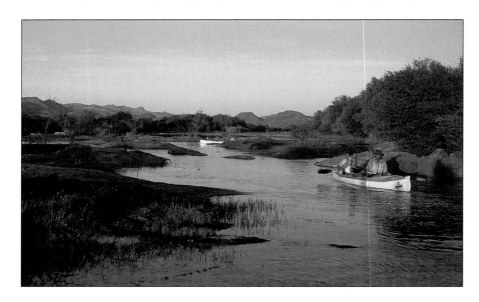

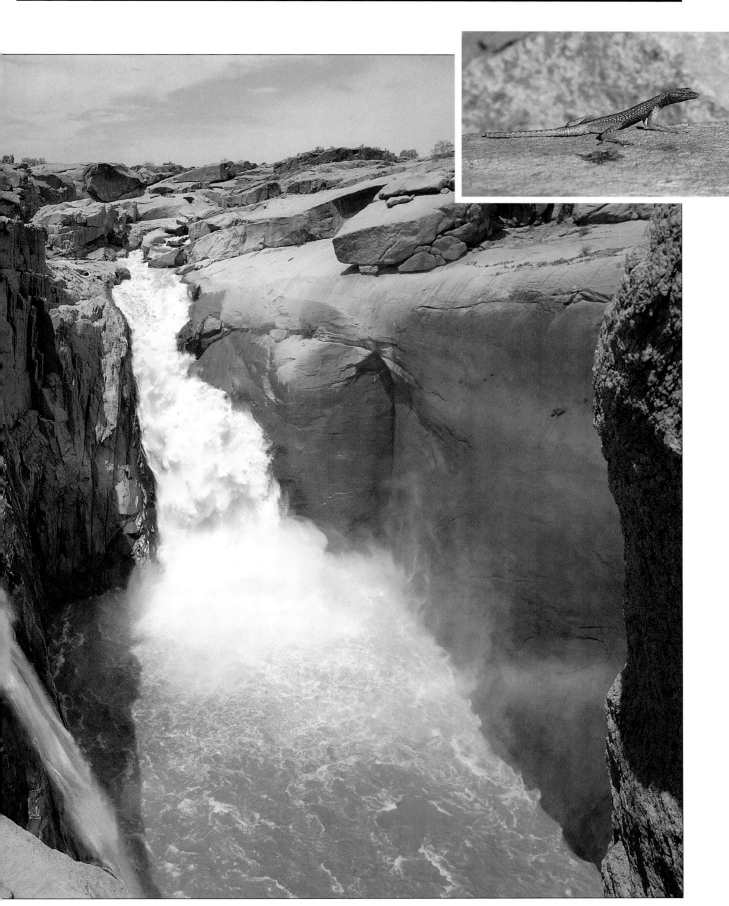

# THE WEST COAST

*Fine fare and flowers*

UITE THE ANTITHESIS OF the luxuriant, subtropical East Coast, South Africa's West Coast is a sort of Karoo-by-the-sea — an arid strip of land with a harsh climate, lashed by the cold Atlantic Ocean, scoured by winds, scorched in summer, and regularly draped in dense mists. Life here is dominated by the sea. In the far north, the prime 'catch' is alluvial diamonds; in the south it's crayfish and snoek, found abundantly in the cold waters of these, the country's most important commercial fishing grounds. Tiny fishing villages and small, busy harbours line the coast. Inland, the farmers harvest the celebrated Sandveld potatoes, as well as wheat and fruit, while the starkly beautiful Cederberg Wilderness Area offers unequalled opportunities for nature-lovers.

It is in early spring that the West Coast truly comes to life. Wild flowers burst into bloom, laying carpets of colour as far as the eye can see. For a few short weeks, flower festivals erupt in every tiny town, and visitors vie for information on the best flower destinations. August and September are the high points of the spring flower season, but displays can begin as early as July and, in good years, may continue until the end of October.

Food, no less than flowers, is a feature of the West Coast and simple eateries serving robust local fare out of doors draw visitors from far and wide. Even Capetonians are prepared to leave the restaurant mecca of the Mother City and drive more than 100 kilometres to eat famous West Coast crayfish, braaied at the water's edge and served in a beachside 'boma'. An annual Crayfish Festival has put the harbour village of Lambert's Bay on the map, and gastronomic renown has come to many of the tiny towns which line the 300-kilometre 'seafood route' from Yzerfontein to Doringbaai.

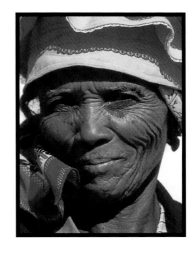

LEFT Namaqualand's arid landscape is transformed with brilliant bands of colour for a few short weeks in early spring. ABOVE This Nama woman is descended from the region's original inhabitants, many of whom moved to Namibia in the nineteenth century.

The wealth and variety of West Coast flora and fauna is remarkable, and a number of sanctuaries have been set aside on land and sea, vlei and lagoon to protect this heritage. One of the world's top four bird sanctuaries — the West Coast National Park — is located just 124 kilometres from Cape Town. The arrival each year of 35 000 curlew sandpipers, which leave their Arctic breeding grounds to spend the summer here, is one of the remarkable features of the park.

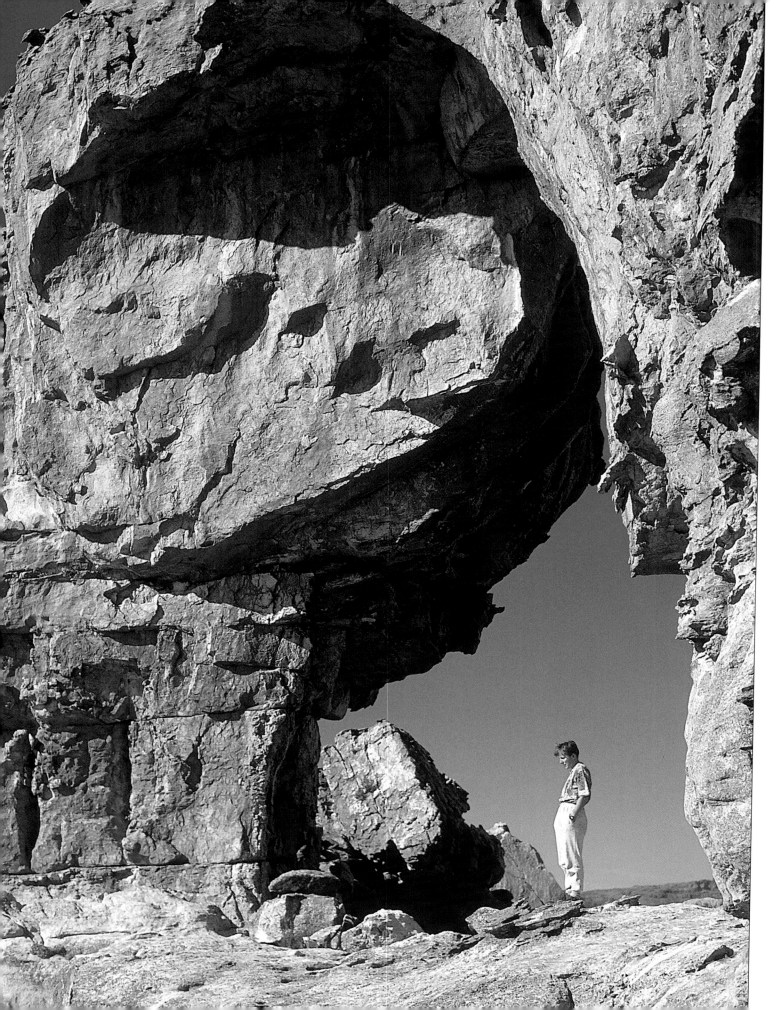

OPPOSITE Reaching the huge sandstone Wolfberg Arch on the Cederberg summit ridge involves a hard day's hike. Gnarled cedar trees and extraordinary rock formations line the route. Weary hikers are rewarded with spectacular views, and can overnight at the Sanddrif huts. From the Wolfberg Arch, the heart of the mountains and all their beautiful and secret places can be explored.

ABOVE Bright red oxides colour the rocks near one of the Cederberg's most famous landmarks, the towering Maltese Cross.

BELOW A family of farm workers travels through the colourful Nieuwoudtville area, a wool and cereal-producing region.

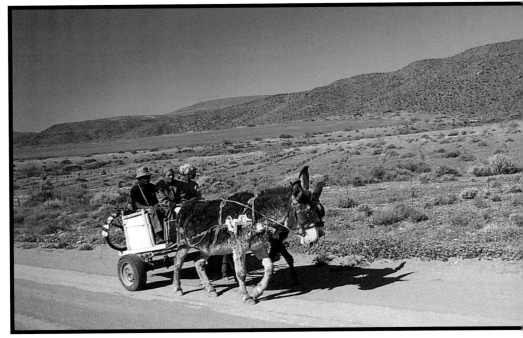

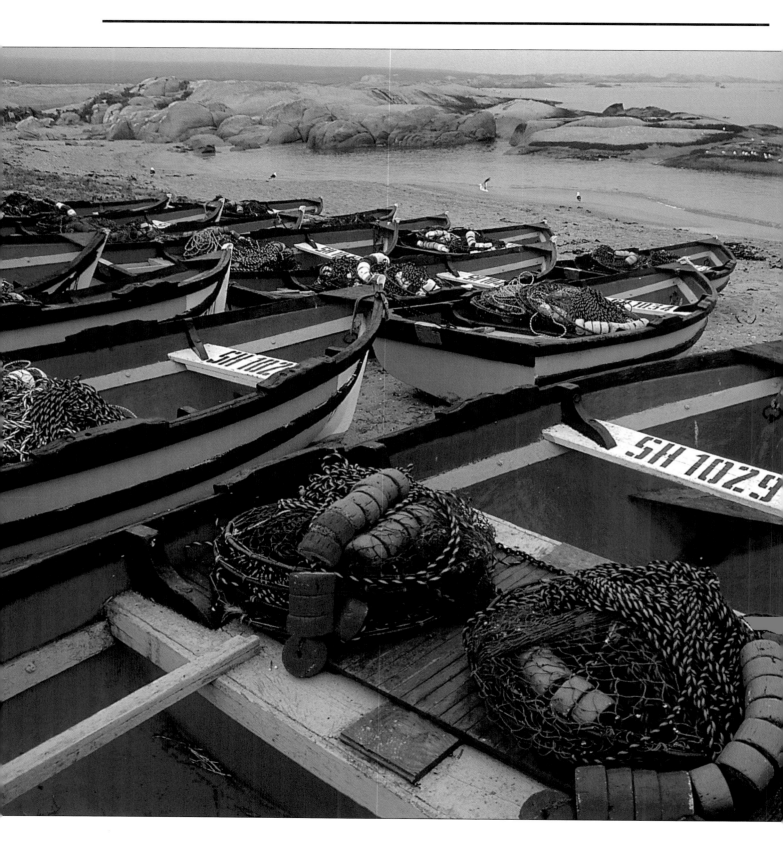

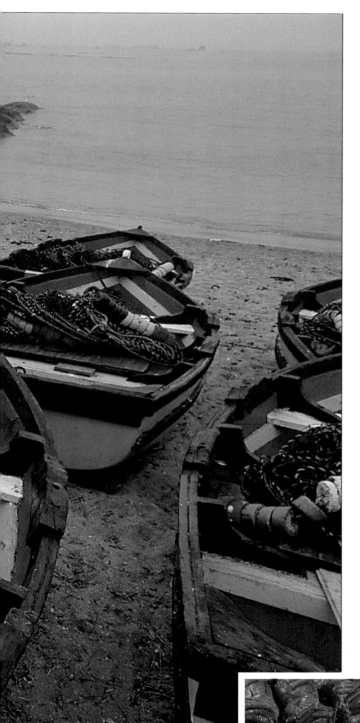

LEFT Orderly rows of brilliantly
coloured fishing boats, at the ready
for another hard day's work, create a
startling contrast against the mono-
chromatic, pre-dawn tones of the small
fishing village of Paternoster (worth
visiting for its perlemoen and crayfish).
ABOVE Modest West Coast hotels
not only offer home comforts and week-
end entertainment for the industrious
farmers and fishermen of the region,
but are also famous for their seafood.
BELOW The West Coast is well
known for its crayfish, which can be
enjoyed at any of the towns along the
'crayfish route', for instance Langebaan,
Saldanha Bay and Lambert's Bay.

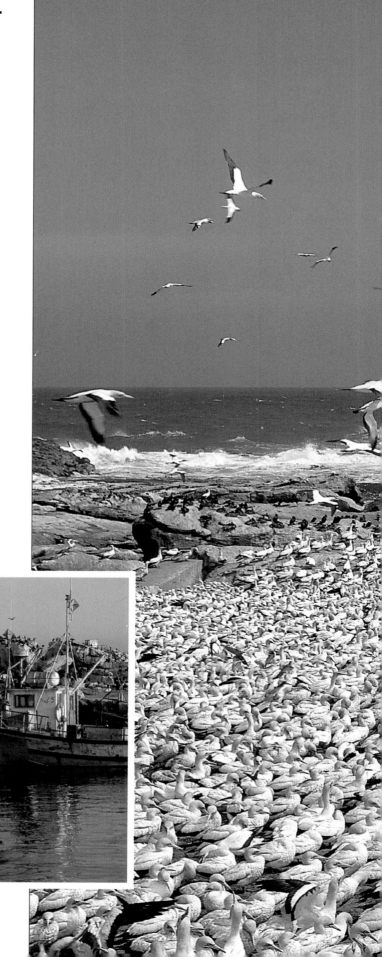

ABOVE  A staple constituent of the West Coast diet, *bokkems* (made from Cape herring or bloater) are heavily salted and strung out neatly to dry in the fresh air.

BELOW  The fishing harbour at Lambert's Bay was the last place where Bartolomeu Dias disembarked before sailing around the Cape. It is also the capital of the 'crayfish coast', drawing up to 10 000 visitors to its annual crayfish festival for a feast of the finest seafood and unpretentious local wines. These placid waters are more commonly seen whipped up by the howling winds that blast the West Coast.

RIGHT  Bird Island at Lambert's Bay provides a sanctuary for 150 different species of birds, among them thousands of noisy Cape gannets *(Morus capensis)*. The 'island' can be reached on foot by means of a walkway from the harbour, and the birds viewed from a wooden observation platform.

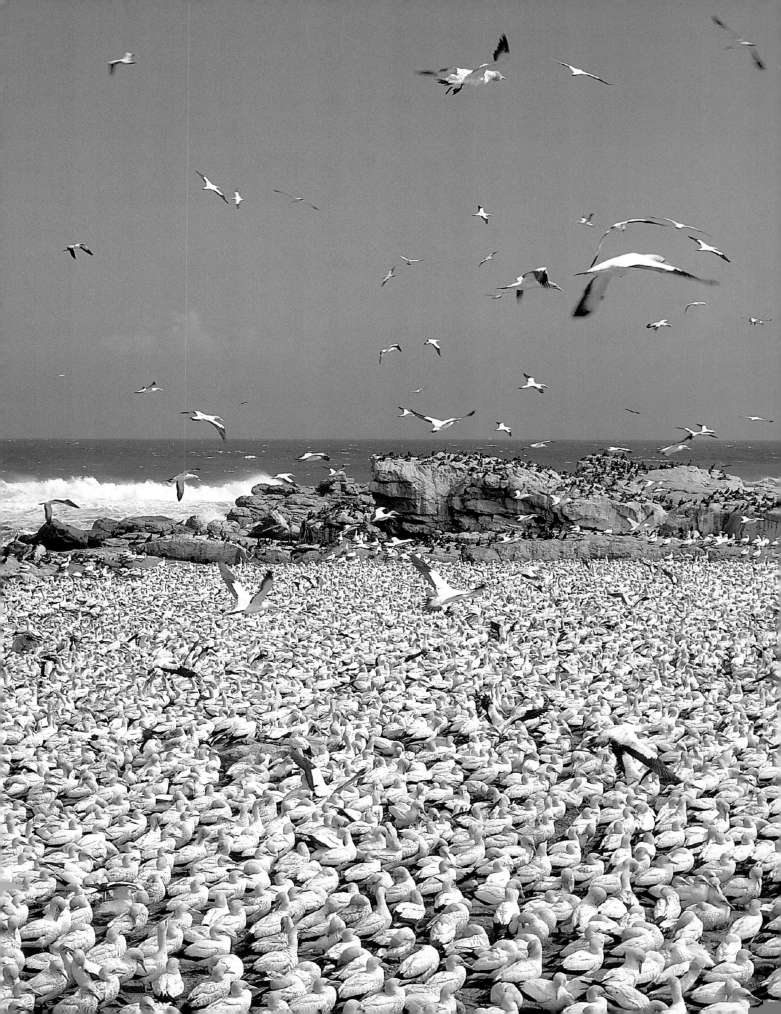

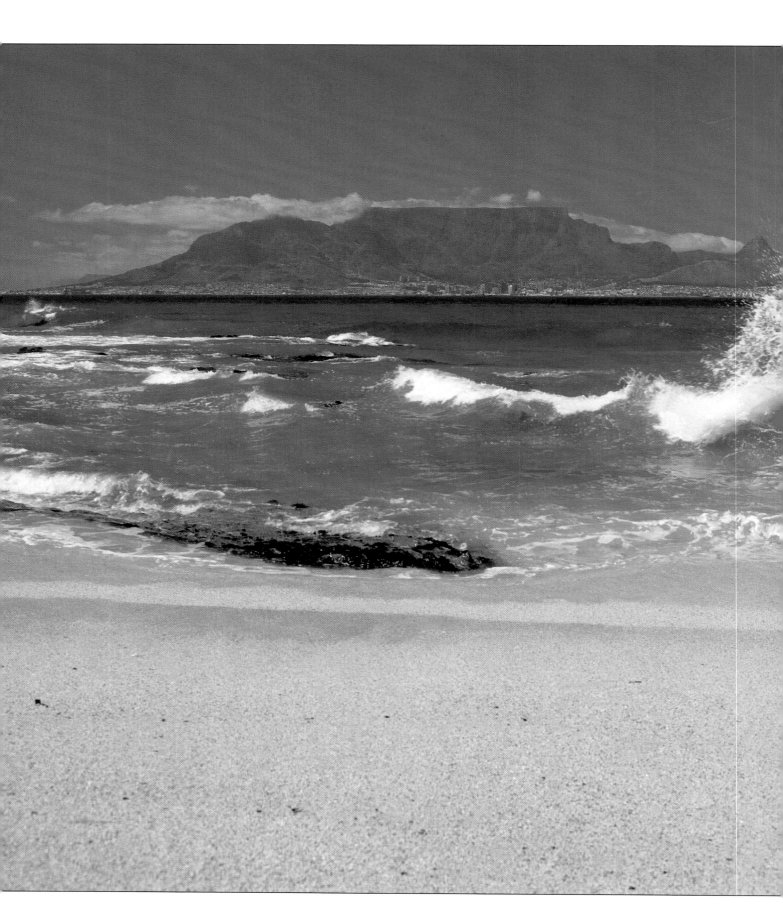

# CAPE PENINSULA AND WINELANDS

*Welcome to Mother's table*

CAPE TOWN, LIKE THE rich girl in the class, has got it all: breeding, beauty and style. Overendowed with assets — mountains, beaches, vineyards, history, architecture and custody of a small, rich floral kingdom. The central, oldest part of South Africa's first city lies in the protective curve of Devil's Peak, Table Mountain and Signal Hill, on land reclaimed from the sea between the lower slopes of the mountain and the blue waters of the bay. Above is the Bo-Kaap or old Malay quarter, a cityside suburb of tiny pastel terrace houses, where people call across narrow cobbled streets and the heady scent of spices hangs in the air. West of the city, the Victoria and Alfred Waterfront, an 80-hectare development in the old harbour, calls the trendy to play. A mecca for shopping, eating and entertainment, it is the world's only working leisure harbour.

The southern suburbs, with exclusive schools and shopping malls, are strung out on the spine of the Peninsula, past Groote Schuur Hospital, the University of Cape Town and Kirstenbosch Gardens. The suburbs wind past

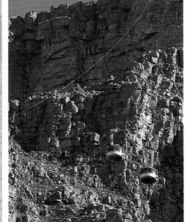

Groot Constantia, South Africa's first wine estate, to Muizenberg through the fishing villages of Kalk Bay, Fish Hoek, St James and Simon's Town, home to the country's fleet. In the west, the apartment/restaurant district of Sea Point eases into a scenic drive from Camps Bay to Clifton (with its famous four beaches), Llandudno, and the holiday resort that grew up around the fishing village of Hout Bay.

Two world-renowned whale-watching sites are less than a day's drive from Cape Town: Hermanus in Walker Bay, or the nearby De Hoop and Postberg Nature and Marine Reserve, where southern right whales can be seen for half the year. Take the road inland through the Hemel-en-Aarde Valley to historic towns such as Caledon, Greyton, Genadendal and

FAR LEFT Table Mountain embedded in a blue sky; a classic portrait of one of the world's most famous landmarks.
LEFT Modern cable cars, carrying up to 65 people at a time, whisk visitors to and from the summit of Table Mountain.
ABOVE The streets and malls of central Cape Town are lined with colourful flower sellers.

Swellendam, or continue along the coast to Arniston, via Africa's southernmost point, Agulhas. Swellendam, South Africa's third oldest town, is flanked by the Marloth Nature Reserve and the Bontebok National Park; the town's assets lie in its whitewashed buildings, some over 200 years old, and avenues of ancient oaks. Swellendam's mountainside setting against the slopes of the Langeberg Range lends further majesty.

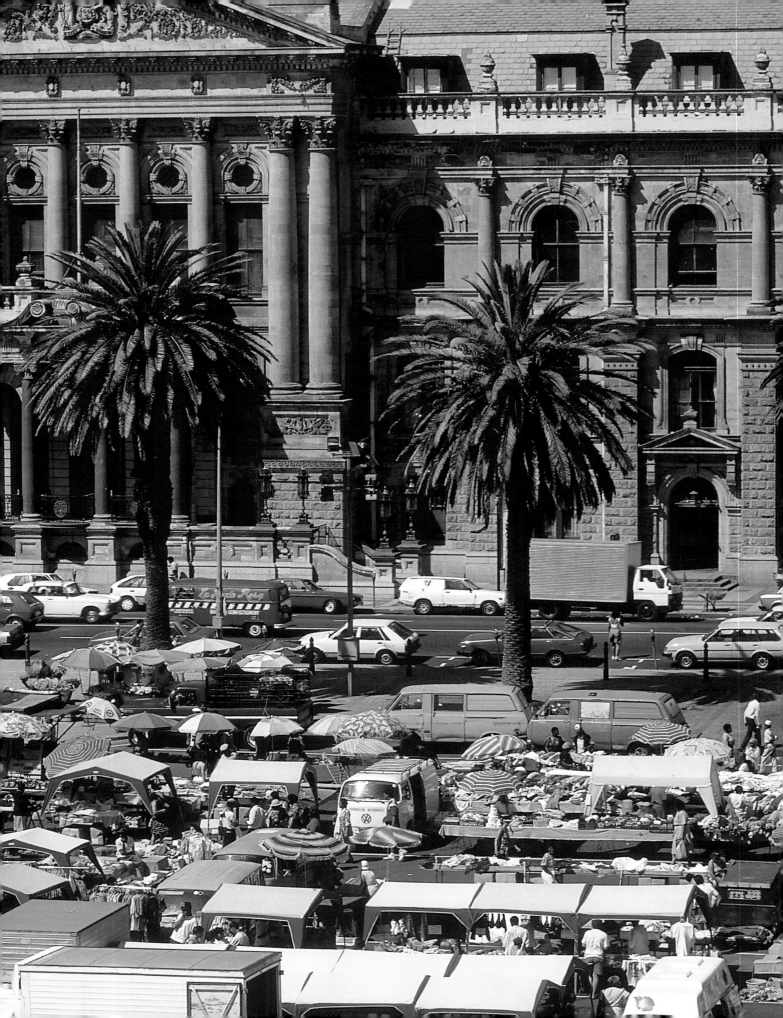

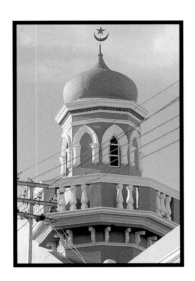

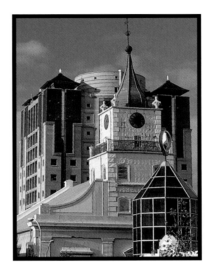

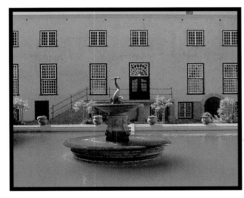

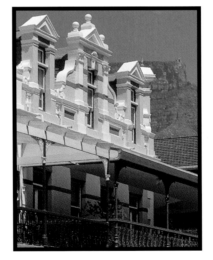

OPPOSITE  Each Wednesday and Saturday thousands of vendors and bargain-hunting shoppers crowd the open-air market on the Grand Parade, Cape Town's oldest public square. The City Hall can be seen in the background.

TOP LEFT  Many of the Bo-Kaap's pastel-coloured mosques date from the eighteenth century.

TOP RIGHT  The historic Lutheran church, built by Martin Melck in 1774, stands unperturbed by its high-tech neighbours in Strand Street.

ABOVE LEFT  The oldest building in South Africa – The Castle, built in 1667 on the site of Jan van Riebeeck's original earth fort – is being comprehensively restored. Early Cape socialite Lady Anne Barnard's quarters overlooked the pool.

ABOVE RIGHT  Cape Town's 'Little New Orleans', Long Street, has numerous well-preserved examples of ornate Victorian architecture.

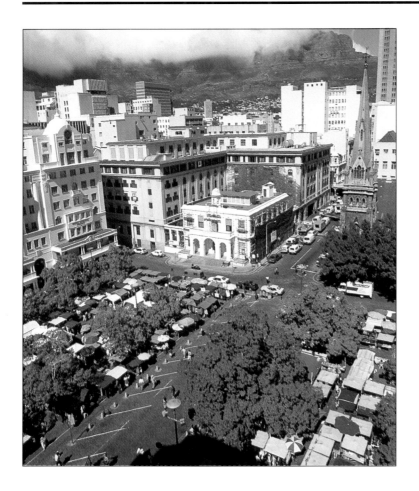

ABOVE  Open-air markets are a feature of Cape shopping. Greenmarket Square, just a block off the city's main shopping artery of Adderley Street, was a fruit and vegetable market serving Capetonians of yesteryear and is today popular with locals and tourists alike.

BELOW  Cape Town, which is the country's rag trade capital, has spawned a burgeoning informal sector for alternative shopping. Locals and visitors comb the flea markets for offbeat clothing, jewellery and accessories.

ABOVE  In a fragrant mall just off Adderley Street, flower sellers offer brilliant buckets full of blooms. Bargaining is friendly and most fruitful after 5 p.m. when the remaining flowers must be sold.

OPPOSITE BOTTOM  New Year in Cape Town is synonymous with the Coon Carnival, when the fiercely competitive minstrel troupes cavort through the summer streets in dazzling costumes.

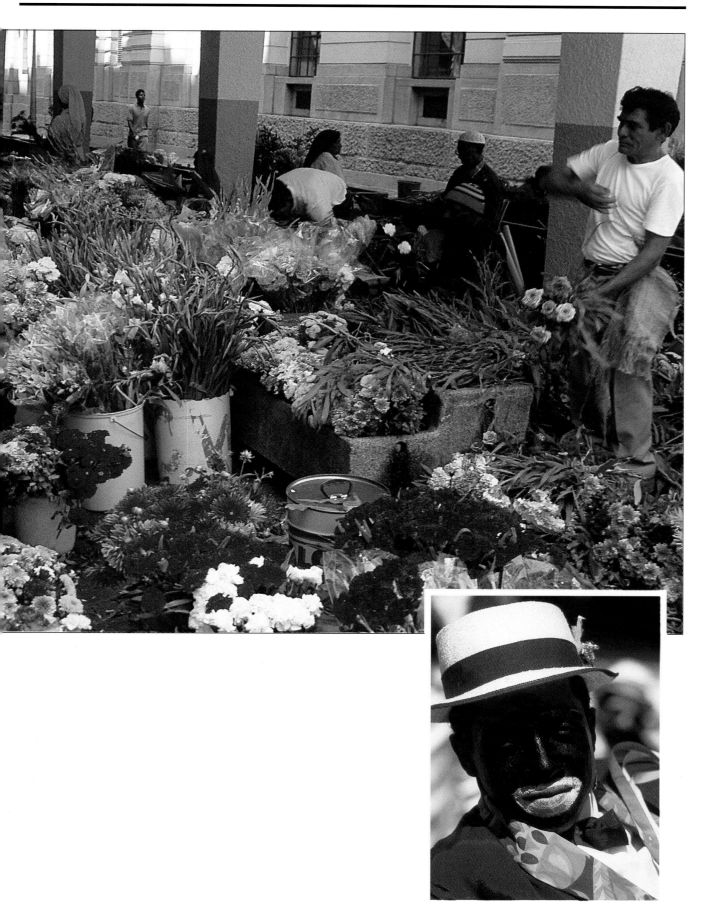

RIGHT  A palace of the consumer king, Victoria Wharf shopping mall at the Victoria and Alfred Waterfront, lit for late-night retailing. The Wharf is one of the few shopping centres in the world where even the parking lot has a view of the sea.

BELOW LEFT  The buskers play on, with or without an audience, creating a perpetual air of celebration at the Waterfront.

BELOW RIGHT  A non-stop stream of visitors goes about the business of pleasure at the V & A Waterfront.

FAR RIGHT  The V & A Waterfront in Cape Town's old harbour, the Alfred Basin, is one of the world's most successful leisure developments and the city's most ambitious man-made tourist attraction. The

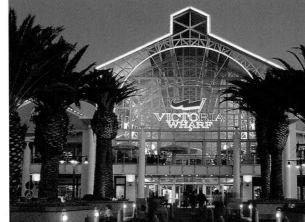

Waterfront is a focal point for shopping, eating, theatre and cinema – or just enjoying the bustle of harbour activities, quayside buskers and a comical group of seals who bark vociferously if their territory is encroached upon.

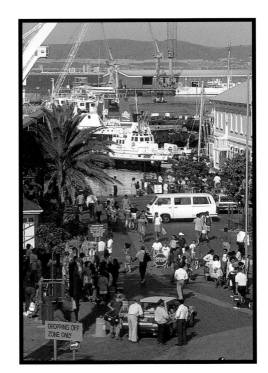

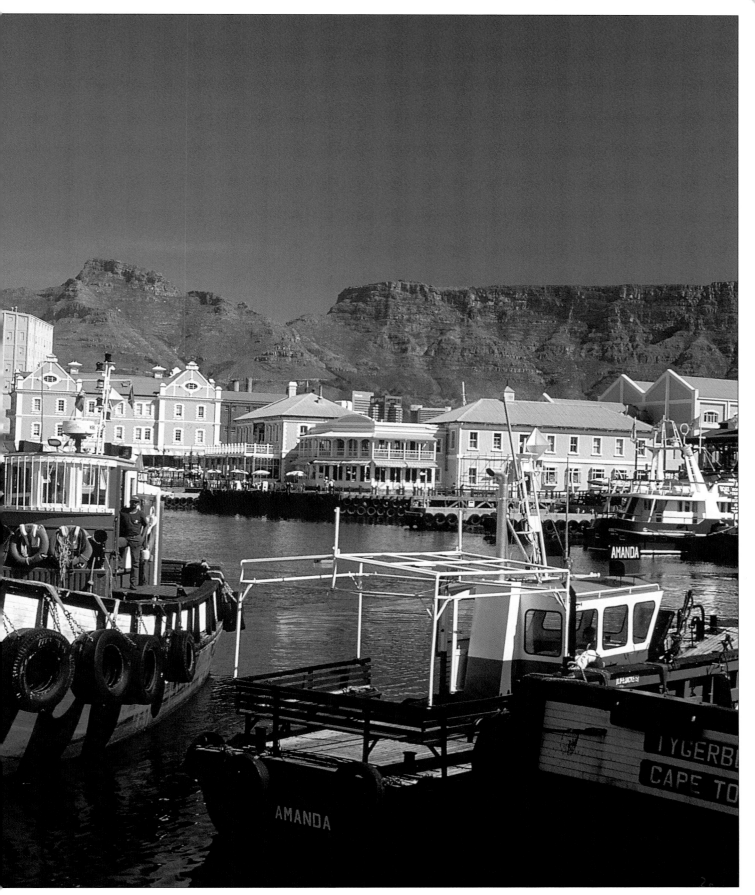

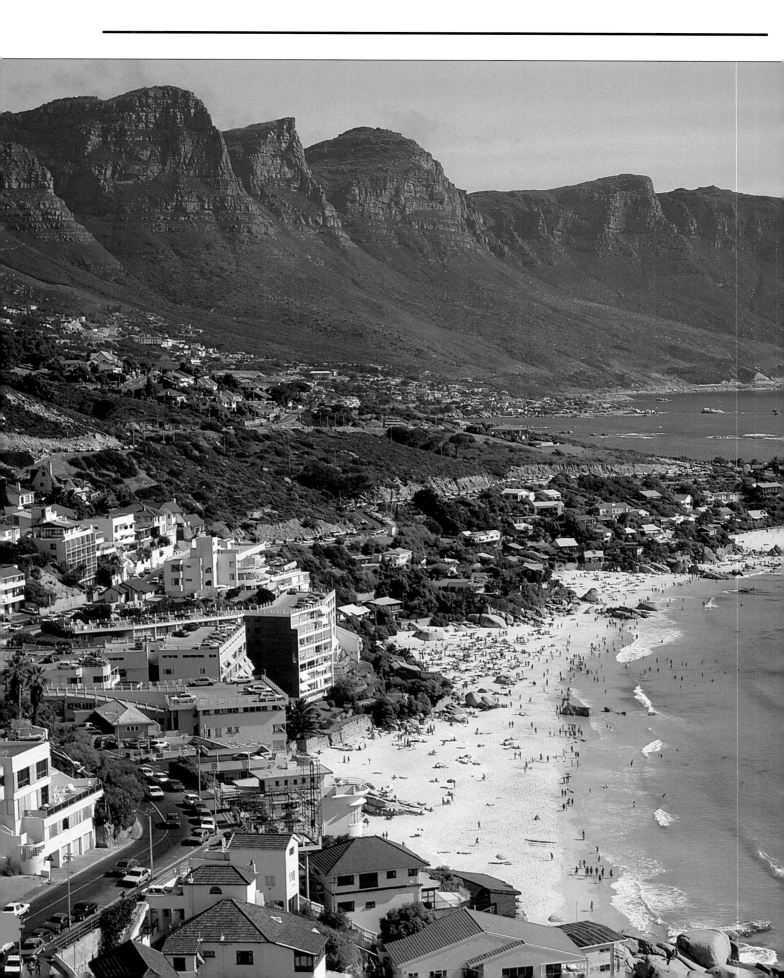

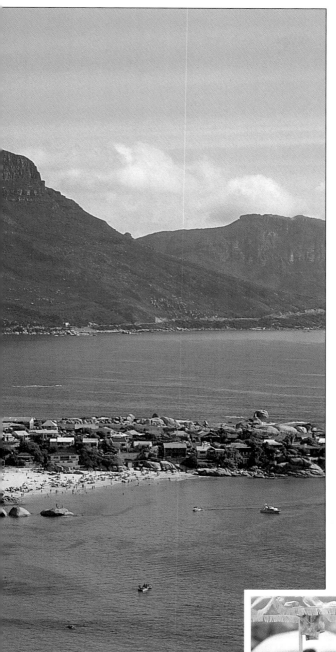

LEFT   South Africa's *Côte d'Azur*, Clifton's famous four beaches in the foreground. Further on are Camps Bay, Bakoven and Llandudno strung out along the feet of the 'Twelve Apostles', a chain of sandstone buttresses which extends the flat top of the Table. Here some of the country's most expensive real estate has been developed on the precipitous western face of Table Mountain, with endless views of the Atlantic Ocean.

ABOVE   The luxurious Bay Hotel in Camps Bay enjoys a splendid setting at the foot of Lion's Head and the Twelve Apostles, just a few steps away from palm-fringed Camps Bay beach. The hotel crowns a strip of stylish cafés, restaurants and bistros that bring to mind Los Angeles or Miami's South Beach.

BELOW   Camps Bay beach, like many Cape beaches, is best in the morning; a surreptitious south-easter tends to rise in the afternoon, building strength until bathers are driven from the beach. When there is no wind, though, the crowds come out.

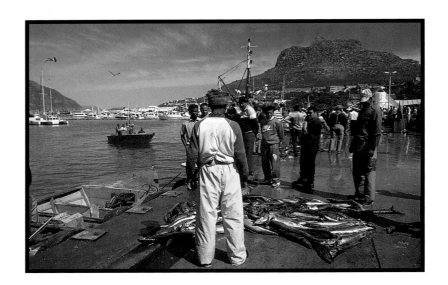

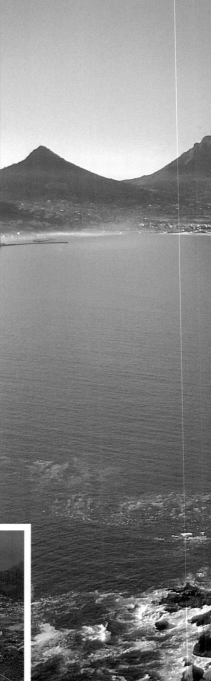

ABOVE Happy haggling accompanies the day's catch of snoek in Hout Bay harbour. The fishing harbour is home base for the large fleet of and lobster fishing vessels, while the beach and sheltered bay provide year-round enjoyment for yachtsmen, boardsailors and windsurfers. Although winter is snoek season, fresh seafood is on the menu at Hout Bay's many eateries all year round.

BELOW Chapman's Peak provides a breathtaking vantage point of Hout Bay and its famous landmark, the brooding Sentinel Rock. The bay ('wood bay') was named for its setting in the dense plantations which provided timber for buildings at the Cape.
RIGHT The scenery of the southern Peninsula unfolds along Chapman's Peak Drive; at its highest the road is some 160 metres above the sea. The village and beach resort of Hout Bay lies in the distance.

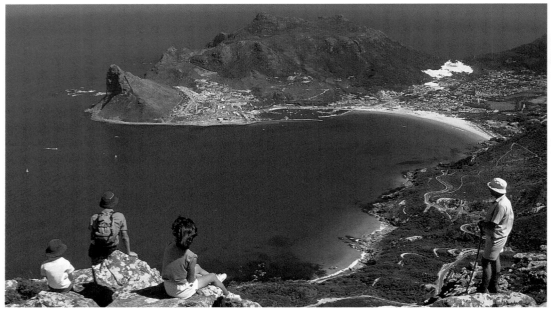

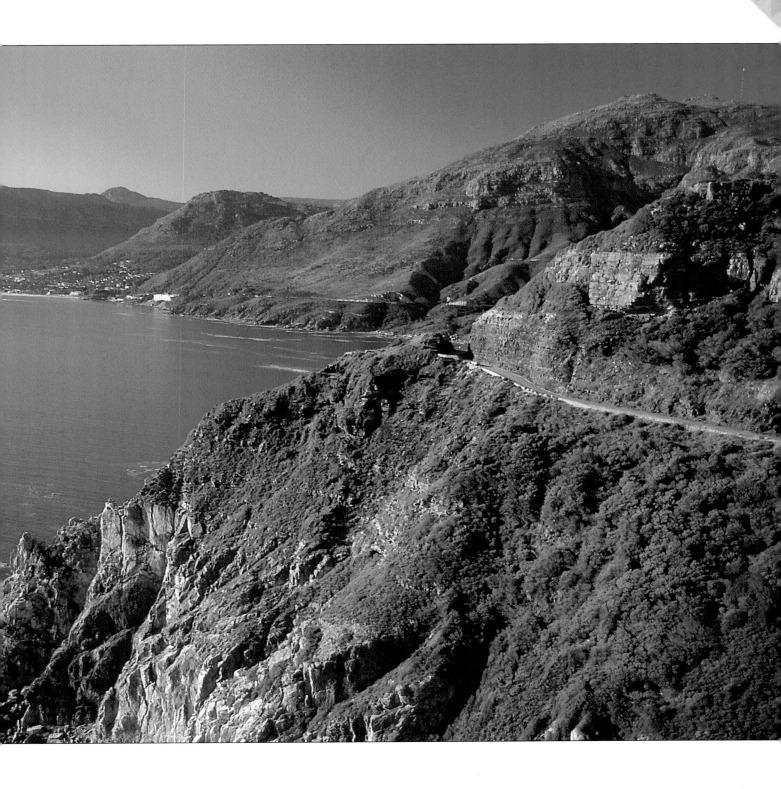

BELOW  The rugged promontory of Cape Point reaches into the chill Atlantic Ocean. Eight-metre-high waves, gale force winds and submerged reefs make *Cabo Tormentoso* truly a Cape of Storms. The greater part of the point is contained in the 7 750-hectare Cape of Good Hope Nature Reserve, a treasury of bird, animal and plant species that thrive along its shores and the varied topography of the interior. The reserve includes 40 kilometres of coastline from Smitswinkel Bay in warm False Bay to Schuster's Bay on the cold western coast.

RIGHT  A scenic drive along the eastern Peninsula to Cape Point meanders through fishing villages and old-world beachside resorts hugging the generous curve of False Bay. The beaches here are safer and about 10 degrees warmer than those on the western Peninsula. The South African Naval Base at Simon's Town is a delightful destination for a day trip by car or via a picturesque commuter train route. The village is reputed to lay claim to the southernmost pub in Africa.

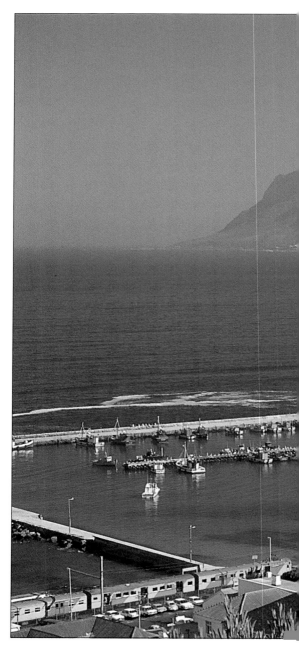

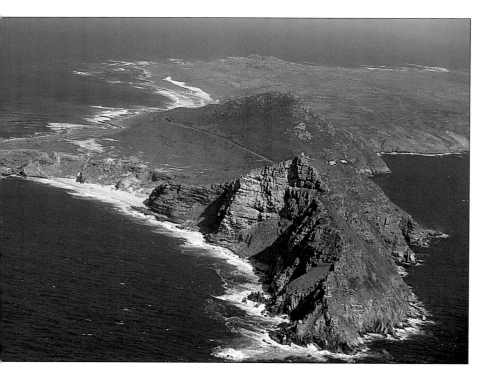

OPPOSITE BOTTOM  The safe swimming and swathes of clean white sand are among the principal attractions of False Bay's beaches, some of which still sport brightly coloured bathing huts, relics of Victorian times.

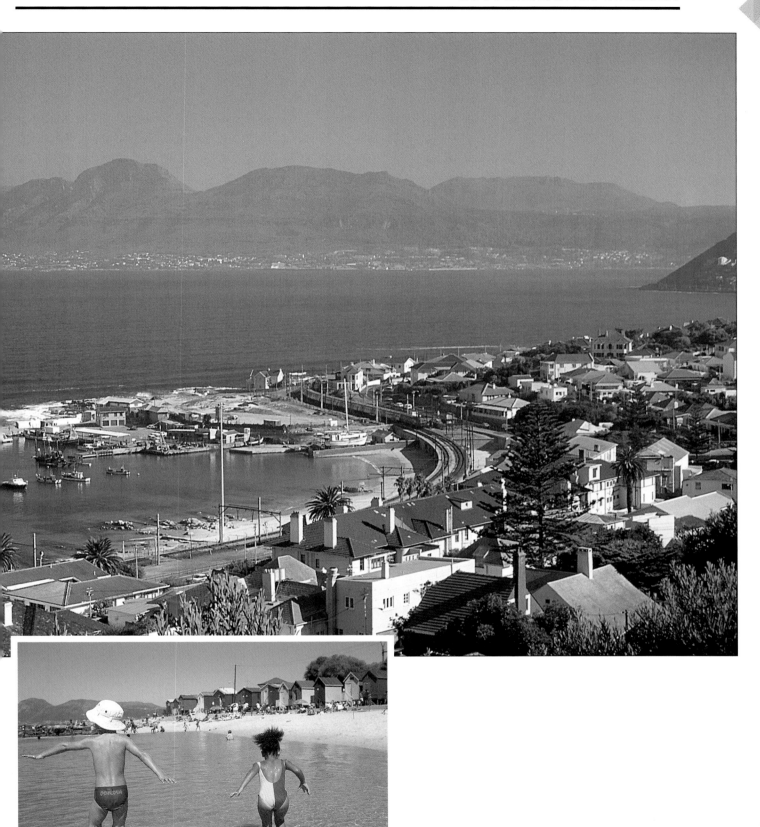

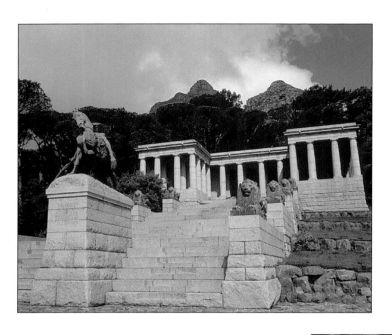

BELOW Groot Constantia, South Africa's oldest wine estate, lies just 20 minutes by road from the heart of metropolitan Cape Town. Originally the home of Cape governor, Simon van der Stel, the estate now includes three independent wine-producing farms, Klein Constantia, Groot Constantia and Buitenverwachting, each with a distinctive cellar of exclusive wines and magnificent Cape Dutch homesteads. The latter two also boast excellent restaurants.

OPPOSITE A legacy from Cecil John Rhodes – the South African National Botanical Gardens at Kirstenbosch. Rhodes' vision was to preserve Devil's Peak and the eastern slopes of Table Mountain as a national park for the 'united peoples of South Africa'. The 528-hectare garden has only 36 hectares under cultivation, with the balance allowed to stand as a glorious natural sanctuary which includes 6 000 species of indigenous plants. The garden attracts more than 400 000 visitors a year.

ABOVE Sir Herbert Baker's memorial to his great friend, Cecil John Rhodes, occupies a commanding position on the upper slopes of Table Mountain, above Rhodes Drive. The towering equestrian statue, 'Energy', is cast in bronze and flanked by a guard of honour of eight bronze lions. Rhodes Memorial is carved from granite taken from Table Mountain where Rhodes walked and rode.

BELOW Antelope enjoy a peaceful habitat in the protected reaches of the Table Mountain reserve area; the lower boundary of the reserve adjoins scenic De Waal Drive which sweeps past the renowned heart transplant hospital, Groote Schuur.

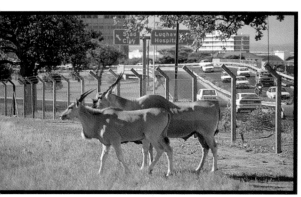

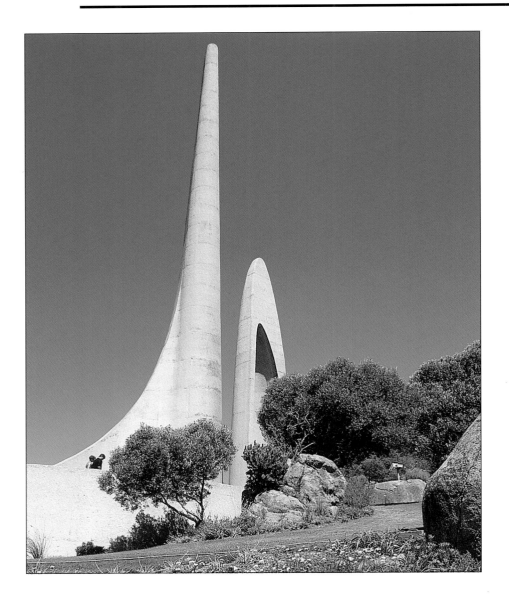

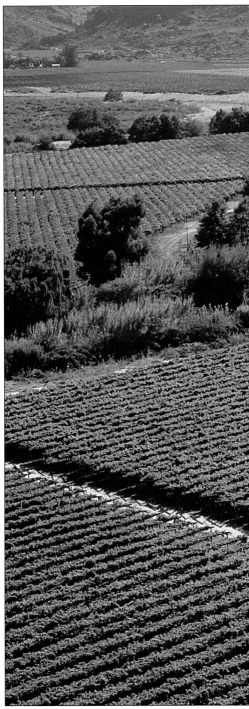

ABOVE On the southern slope of Paarl mountain stands the Afrikaans Language Monument; in the town, the Gideon Malherbe House in Parsonage Lane commemorates the birthplace of the 'society of true Afrikaners' *(Genootskap van Regte Afrikaners)* founded there in 1875, which laid the foundations of the language.

RIGHT De Doorns is easily bypassed on the Cape Town to Johannesburg highway, but travellers would be well advised to stop and savour the sweet dessert wines, port and delicate grape juice produced by several cellars in the district.

OPPOSITE BOTTOM Harvesting *waterblommetjies* (little water flowers) for the famous Boland stew, *waterblomme-tjiebredie.* The plants add a fresh green bean flavour to the succulent casserole of lamb and potato. A hearty dish for the winter months, it is served with lemon, freshly ground black pepper and rice.

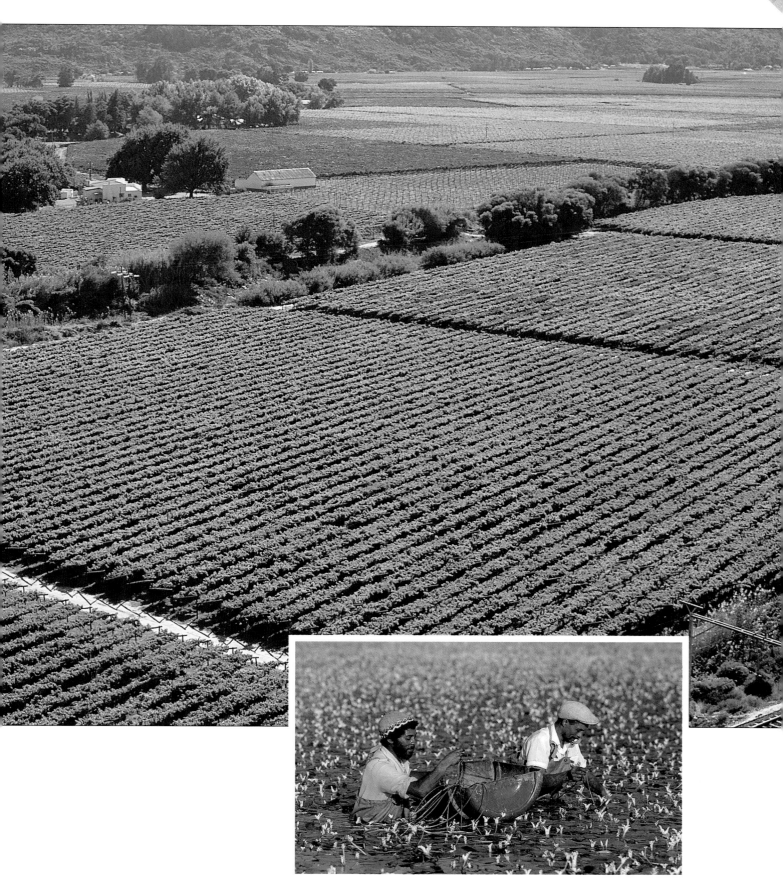

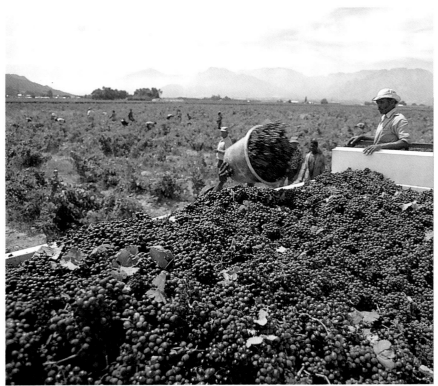

ABOVE From the cool coastal regions to the hot, dry interior, wine is made all the way from the near West Coast to the Little Karoo; up the West Coast and across the Swartland; at Piketberg in the Sandveld and along the banks of the Olifants River; and north as far as the Orange River.

RIGHT Paarl's elegant Nederburg manor house dating back to 1792 is the setting for an annual wine auction of world renown. The H-shaped dwelling with ornate gables has been perfectly preserved and occupies a glamorous setting on a carpet of vines lining the floor of the Berg River Valley.

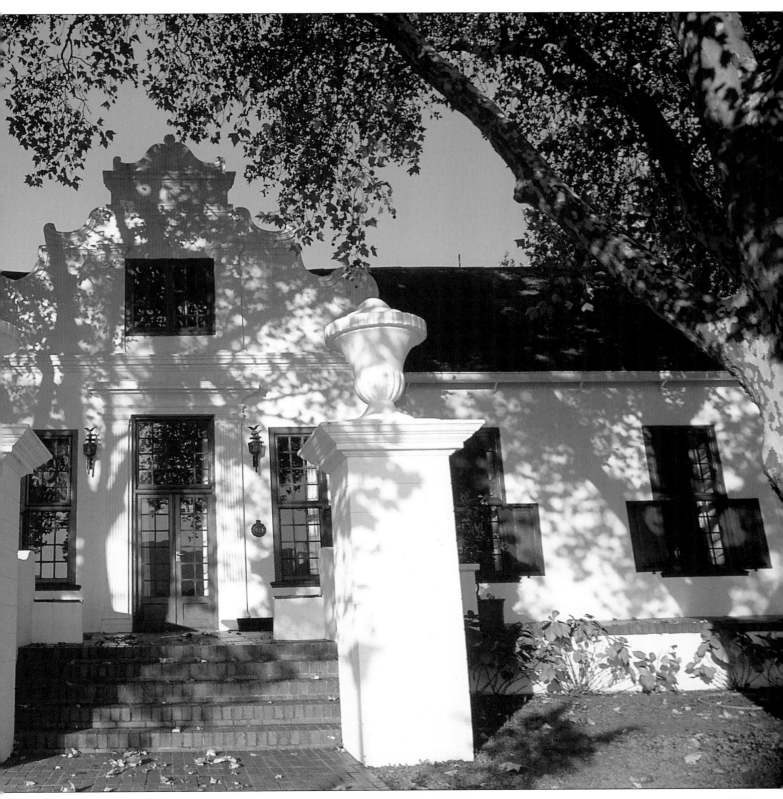

RIGHT With its many contrasting micro-climates and soil types, the Stellenbosch wine region produces 280 different wines, both red and white, from fine cultivars. There are 18 wine estates and five major co-operatives open to the public within a 12-kilometre radius of the town. Stellenbosch vignerons established the first South African wine route 24 years ago, leading the way for 12 other regions to do the same, spawning a major industry.

ABOVE Oom Samie se Winkel in Stellenbosch, an old-time trading store (selling home-made goods such as preserves and pottery), and a coffee shop.
RIGHT One of Stellenbosch's many delightfully relaxed eateries.
BELOW The town has many fine Cape Dutch buildings and South Africa's most important avenue of historic oaks.

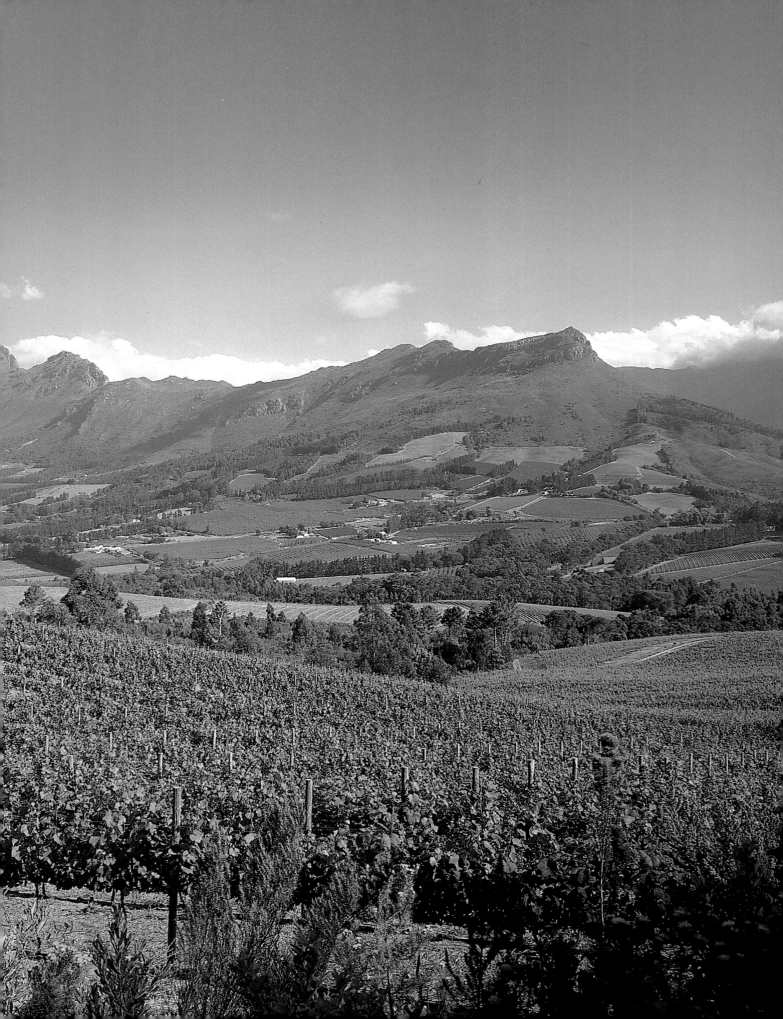

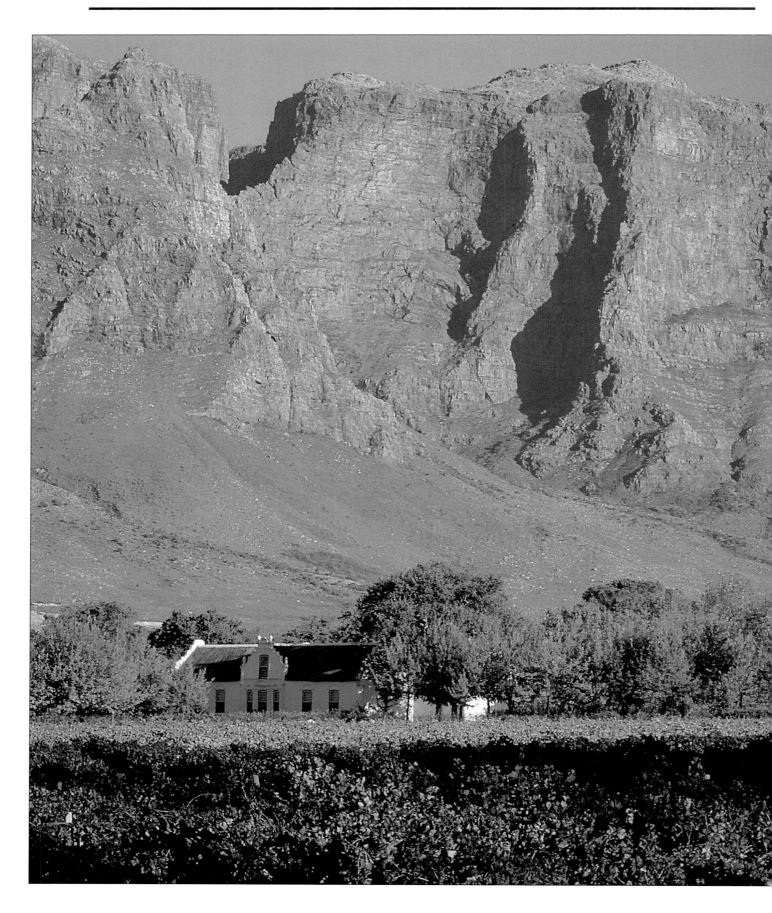

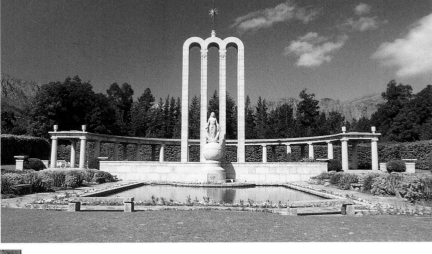

LEFT  The Boschendal manor house is a glorious example of Cape Dutch farm architecture, with a whitewashed, H-shaped homestead and numerous outbuildings elegantly placed against a backdrop of the Groot Drakenstein Mountains. The house contains Dutch East India Company furniture and porcelain and is open to visitors. Picnics on the lawn under the oaks are a delightful way to while away a summer afternoon. The estate also has a fine restaurant.

ABOVE  When the Huguenots fled from religious persecution in Europe, they brought with them French culture and the rudiments of winemaking – a turning point in South Africa's economic history. The Huguenot Monument at Franschhoek commemorates their struggle for religious freedom. The beguiling little town of Franschhoek, original home of the French Huguenots, is celebrated for fine food and wine. Charming restaurants are dotted about the town and district.

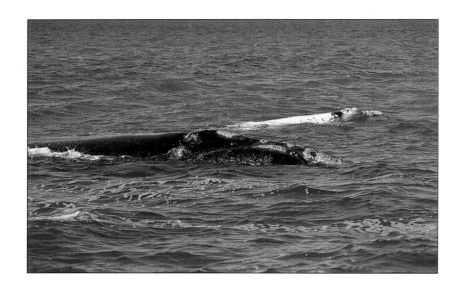

OPPOSITE TOP  A bracing walk along the popular cliff path deserves the reward of tea and scones – with a sea view – at one of the town's many charming restaurants.
BELOW  The delightful coastal resort of Hermanus grew from a fishing village; now it is a popular destination for the 'who's who' of holidaymakers and for the many top executives who have second (or third) homes there, a kind of 'corporate headquarters by the sea'.

ABOVE  Hermanus is renowned as one of the world's premier whale-watching sites for southern right whales. There are only about 4 600 remaining in the world, and international whale-watchers track their movements closely. Here a southern right cow with a white calf lazes in the shelter of Walker Bay.
BELOW  The whale crier is a quaint sight with his sandwich board and kelp horn; he advertises the best spots for whale sightings during the season, July to December each year.

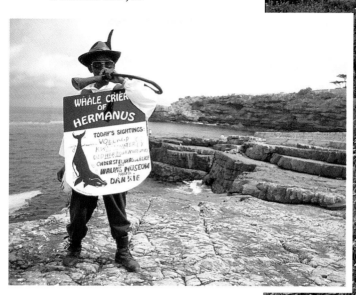

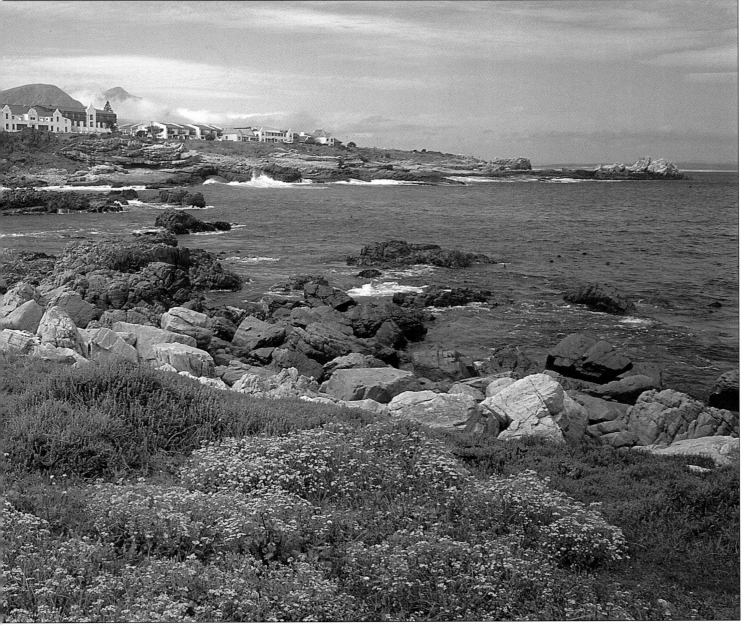

BELOW Since 1849, the lighthouse at the southernmost tip of Africa, Cape Agulhas, has warned ships of the dangers of this treacherous stretch of coast. Here, it is said, is where the two oceans, Indian and Atlantic, meet. Known as the Strandveld, the region is famous for superb *fynbos* and birdlife, while inland are rolling fields of wheat, barley and oats and fine stock-raising country. The nearby coastal settlements of Struisbaai and Arniston, and, inland, Bredasdorp and Swellendam, are charming destinations for excursions from the Cape Peninsula. Yet another attraction is the De Hoop Nature and Marine Reserve, incorporating more than 45 kilometres of shoreline east of Bredasdorp; this is another important whale-watching site, where southern rights breach offshore for six months each year.

RIGHT Serene surroundings just outside of Swellendam, a town that is steeped in history and renowned for its fertility — wheat and fruit, dairy, sheep, cattle and horses are all produced or bred in the tranquil valley at the foot of the Langeberg. Swellendam's history is recalled in the beautiful old Drostdy Museum and a group of workshops on the complex where the tools of forgotten trades are on display. The town's other most notable buildings are the old jail, the burgers' meeting house *(Oefeningshuis)* the Barry family's Auld House, Boys' School, local council houses *(Heemradenhuis)* and a tiny T-shaped house in old Cape style, The Cottage.

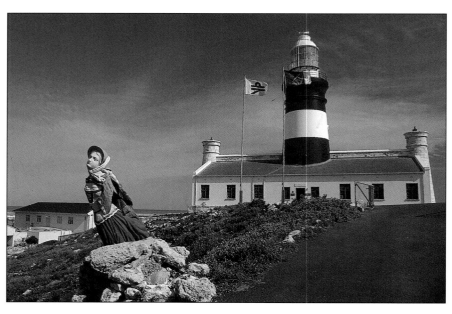

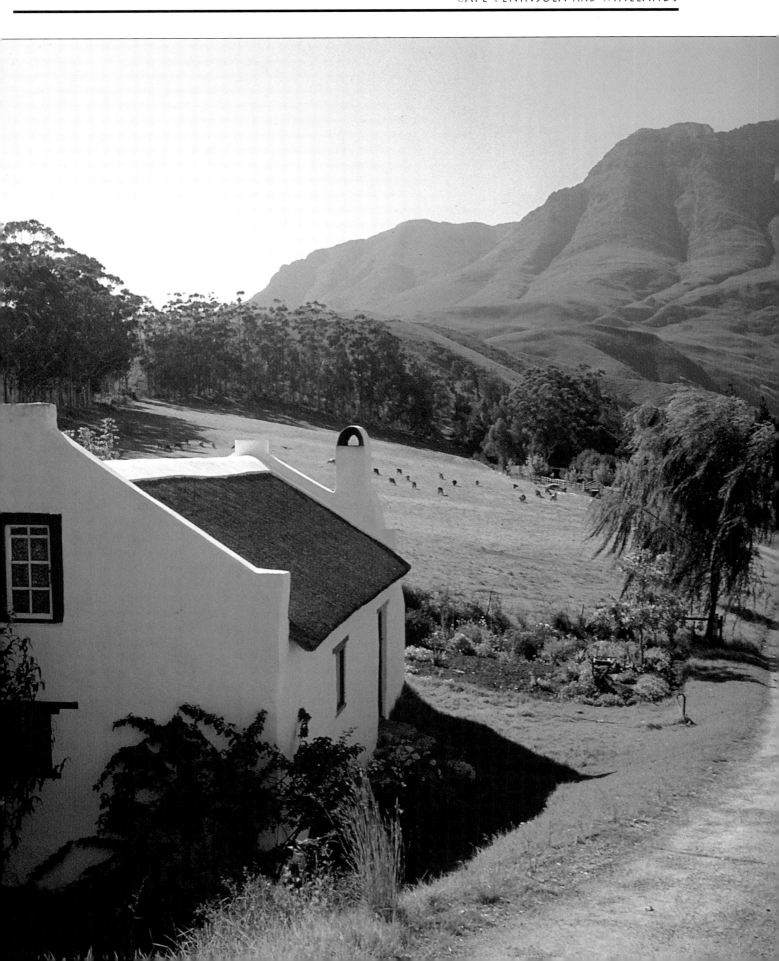